FOOD
IN
FOCUS

FOOD
—IN—
FOCUS

Charlotte Plimmer

AMPHOTO
AN IMPRINT OF WATSON-GUPTILL PUBLICATIONS/NEW YORK

Created and produced by Phoebe Phillips Editions, 1988

Copyright © 1988 by Phoebe Phillips Editions

First published 1988 in New York by AMPHOTO,
an imprint of Watson-Guptill Publications,
a division of Billboard Publications, Inc.,
1515 Broadway, New York, NY 10036

Library of Congress Cataloging-in-Publication Data

Plimmer, Charlotte
 Food in focus.

 Includes index.
 1. Photography of food. 2. Food—Pictorial works.
I. Title
TR656.5.P55 1988 778.9′96415 88-3397

ISBN: 0-8174-3894-7
ISBN: 0-8174-3895-5 (pbk)

Manufactured in Italy
Designed by Phil Kay

1 2 3 4 5 6 7 8 9–96 95, 94, 93, 92, 91, 90, 89, 88

Contents

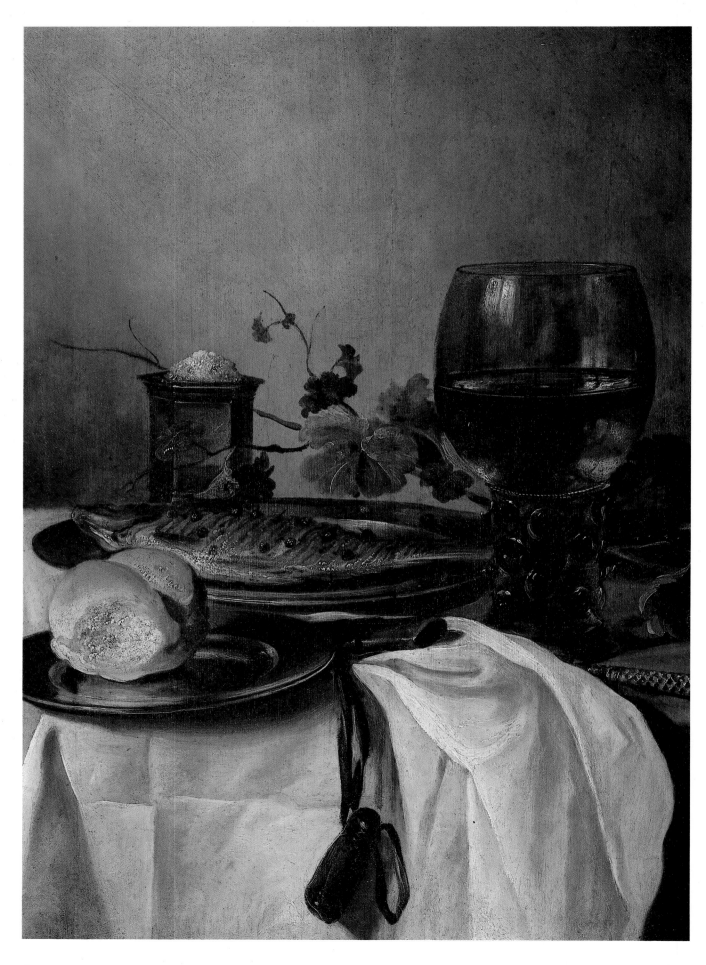

Introduction

We spend more time with our food—growing it, catching it, buying it, cooking it, eating it—than with any other single human endeavour. This includes even sleeping and all the other joys of bed. So it is little wonder that, dating at least as far back as the high civilization of the Greeks in the sixth century B.C., gastronomy has been a multi-sensual and not merely a gustatory art, with food savoured almost as much for its visual appeal as for its flavour.

Upwardly mobile Romans, who imported Greek servants to refine their tastes in cookery as well as in the arts, letters and the law, made of their meals glorious orgies in which all the senses were stimulated. Banquets were splendidly ostentatious affairs, set out on ivory-inlaid tables decked with gem-encrusted plates and ornate glassware. The food was rich, opulent, highly spiced and endlessly experimental.

Meat, fish and game were grilled or spitted whole, pounded into sausages or croquettes, and served with custard-like side dishes, puréed vegetables or thick honey-based sauces. Roman cooks became extremely prosperous and influential and in turn repaid their masters by titillating their palates with anything that seemed remotely cookable, from wild ass to camel, chestnut-fattened dormice to newborn puppies. Some even tried elephant.

Recipes in imperial Rome were already being codified and recorded, a practice instigated much earlier by the Greeks, who produced a large and sophisticated gastronomic literature. In Attica even apprentice cooks were taught by the book. Almost all these ancient writings were, unfortunately, lost in the disastrous fire that destroyed the great library at Alexandria in 48–47 B.C. Only the names of some authors and a few scraps of manuscript were spared.

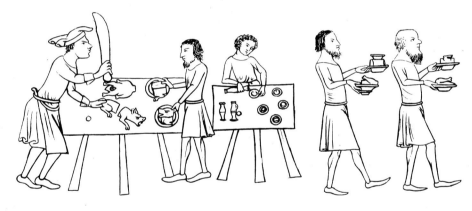

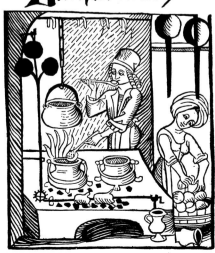

The most famous to have survived are fragments by Archestratus, a poet of the fourth century B.C., which are sometimes referred to as history's first cook book. Archestratus was not, however, a cook, but a wandering gastronome, a kind of Odysseus of the taste buds, who travelled widely on land and sea, discovering what people ate, searching out the best that was to be had and singing its praises.

It was a Roman named Coelius Apicius, who lived at about the time of Christ, who is credited with the oldest known collection of recipes in existence. An impassioned diner, both a glutton and a gourmet, he ran classes in fine eating, squandered a fortune on his belly and committed suicide rather than face the rigours of more meagre rations.

Although many of the dishes he recorded were elaborate, his notes seem to have been rather hasty simple jottings which merely listed ingredients without giving quantities and left the intricacies of procedures pretty much up to the cooks to puzzle out for themselves. One collection attributed to him, but padded with domestic notes derived from the work of Greek epicures, dates from the fourth century A.D. *De Re Coquinaria*, the first printed Apicius book, appeared in Milan in 1497. There have been numerous translations and editions since, and frequent hot arguments among culinary scholars as to their authenticity.

Other cook books printed during the infancy of movable type had preceded the Apicius by over two decades. The earliest, Manfredi's *Liber de Homine*, was produced

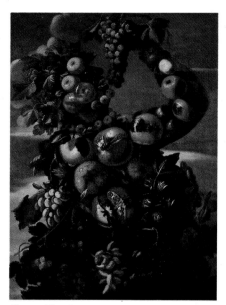

Above: The sixteenth-century Italian painter, Arcimboldo, created fantastic, symbolic portraits from the clever arrangement of fruit and vegetables.

in 1474. This was a scant nineteen years after the Gutenberg Bible, the first printed book of all, a coincidence of timing which would seem to make a significant comment on people's priorities. Owen Meredith, Earl of Lytton, put the position into perspective some four centuries later:

> We may live without poetry, music and art;
> We may live without conscience and live without heart;
> We may live without friends; we may live without books;
> But civilized man cannot live without cooks.

From the fifteenth century onwards books on cooking and gastronomy, on herbs and spices, and on general household hints, have constituted a substantial portion of publishing, the numbers growing ever greater over the generations until, in our own time, they pour forth from the presses in a massive torrent. Illustration has always figured importantly, for the things to do with cooking—the cauldrons and vessels, spits and braziers, table settings and dining scenes, to say nothing of the actual foodstuffs—are intrinsically pleasing to look at. Medieval books were handsomely decorated with woodcuts, and those of later periods with plates and engravings.

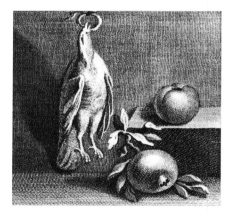

Right: During the eighteenth century, the great interest in gastronomy was matched by high-quality engravings designed to inform the reader; these examples show the contents of a game larder.

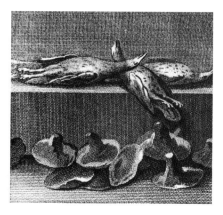

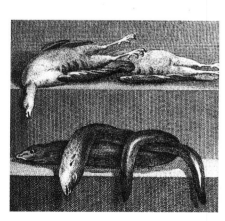

 Food preparation in itself became in the hands of some masters a spectacular art form. Supreme among these was Antonin Carême, chef at various times to Talleyrand, Napoleon, the Prince Regent, the Czar of Russia and Baron de Rothschild, who created toweringly magnificent set pieces for the table and maintained that confectionery was the chief off-shoot of architecture.

 The natural beauty of food was celebrated most brilliantly of all, of course, by the still-life painters of the sixteenth and seventeenth centuries. It is this aesthetic tradition, nourished mainly by Flemish and Spanish artists, which has been passed down to us in today's glamorous cook books.

 No sooner had photography been invented in the nineteenth century than lenses began to be aimed at the things we eat. The camera emerged as a practical working

Right: Seventeenth-century artists, like the modern photographers in this book, used food as much for its colour, shape and form as for its content.

object in about 1839, and although everything to do with taking pictures was cumbersome, the fledgling art attracted stubborn adherents who were willing to prepare their own bulky wet plates and to stand with stony patience beside their tripods, enduring long exposure times which invariably took many seconds and could sometimes last for minutes.

Despite such odds, startlingly beautiful photographs were produced, and the still life—dependably non-fidgeting—became a popular subject. Among the first photographs on record is one of a basket heaped high with fruit, taken in 1842 by William Henry Fox Talbot, the English photographic pioneer. Several years later he illustrated a series of pieces entitled *Pencils of Nature* with still lifes which, although grainy and sombre, were in compositions reminiscent of the Flemish masters.

Other photographers were experimenting in similar ways, encouraged by steady

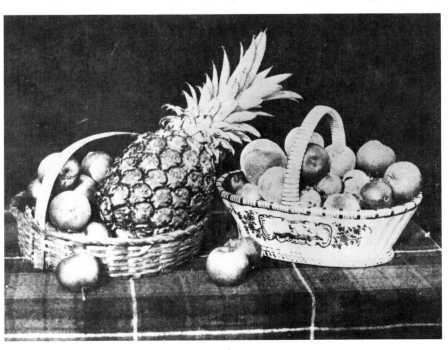

Right: A photograph from Fox Talbot's Pencils of Nature, *taken in April 1846.*

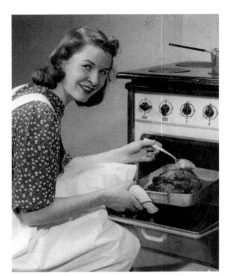

Above: This photograph from the 1950s instructs the cook to baste a roast well to ensure tenderness.

Below: This illustration from the Household Encyclopedia *(1939) shows a range of made-up dishes.*

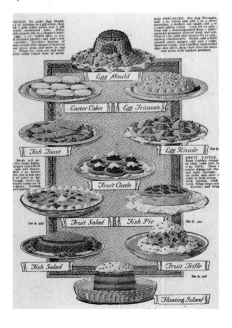

technical advances which included a dry plate coated with silver salts in a solution of gelatine. Far more sensitive to light than the wet plate, it drastically reduced exposure times. Hand cameras with efficient lenses and built-in shutters were also beginning to appear. By the turn of the century, speeds as fast as $^1/_{1000}$ second were already possible.

The box Brownie, using Eastman Kodak's marvellous new invention, roll film, was launched in 1900. It sold for one American dollar and quickly attracted a wide amateur following. Professional photographers meanwhile revelled in the introduction of the half-tone process which made reproduction relatively cheap and easy. Before long, pictures began to appear in cook books.

Colour photography, however, without which food photography could not be truly compelling, was still a long way from being a practical everyday reality. The first colour picture, a recognizable image of a red, green and blue ribbon, had been achieved as early as 1861 by James Clark Maxwell, a Scot, but after that progress was limpingly slow.

The public complained that portraits in black and white or sepia were corpse-like and clamoured for natural skin tones. Fox Talbot, while himself experimenting with colour processes, was one of many who responded by producing prints on special papers that could be painted with watercolours or transparent oils. Kits for amateur tinters were widely sold, and commercial photographers offered a choice of finishes, the painted costing at least twice as much as the plain photograph.

Eminent physicists and photographic technicians searched ceaselessly for materials sensitive enough to record directly and for simple techniques. Their names ring down the ages, among them Herschel, Daguerre, Lumierè, Zeiss. In the late 1880s, an American, Frederic E. Ives, invented a printing process and a couple of cameras— one for straightforward photographs and the other for stereoscopic pictures— based on complicated systems of mirrors and reflectors which finally produced discernible colour separation. His successful prototypes included a basket of fruit and a watermelon which had been cut open to reveal its rosy, juicy flesh.

Colour printing remained difficult, however, into the first decades of the twentieth century, despite the introduction of an ingenious variety of plates, films and processes. But the mere fact of their existence was enough to spur the producers of cookery books. "With upwards of 120 illustrations of which 28 are in full colour," boasted the title page of a popular everyday manual published in London and New York in 1929. These were cold, greyish, drab, little pictures, crammed three or four to a small page, unappetizing and not even very informative.

It was not until the 1930s, thanks to the invention of Agfacolor in Germany and Kodachrome in the United States, that colour reproduction became reasonably effective and dependable, but still only reasonably so. Prints tended to be muddy and pallid and their use was still something of a novelty. The much-heralded first edition of *Larousse Gastronomique*, published in Paris in 1938, included *"36 planches hors texte en couleurs."* Considering that it was a massive and expensively produced volume which also contained 1,850 *gravures* in black and white, this was hardly a giant step forward.

World War II, of course, abruptly halted progress in photographic refinements for civilian use, but numerous advances in techniques, equipment and materials were evolved for military purposes which greatly enhanced what was offered to the public when hostilities ceased.

One direct result was the emergence of an entirely new profession, that of the professional food photographer. The popular women's magazines exploded with colour. Recipe pages and advertisements alike became abundant cornucopias that spilled over with gastronomic wonders. As taste grew even more adventurous with the ending of post-war austerity and the surge of post-war travel, cook books burgeoned and bloomed. It was a period of extraordinary culinary exuberance, but it was tainted, unfortunately, by certain insalubrious photographic conventions. Foodstuffs were cosmeticized as though they were Ziegfeld chorus girls; realism was all too often sacrificed for the sake of an oleaginous gleam, and trickery was rampant. Mashed potatoes, for instance, frequently stood in for ice cream and papier maché mock-ups were sometimes blatantly passed off as genuine meat or poultry.

These clumsy substitutions soon tapered off, however, as cameras and film attained unprecedented speed and sensitivity. Actuality has been the general rule since the 1960s. Some photographers still occasionally use substitutes that are more compliant than the real thing (several such shots appear in this book), but most are now dedicated to absolute naturalism and utter honesty. Any tricks are employed tend to be tricks—perhaps "skills" is a better word—of execution, not substitution, of a studied and sophisticated technique.

Today's food photography accurately reflects the nuances of its subject matter, making flavours and fragrances seem almost palpable. It is sometimes highly stylized, often sensually evocative, sometimes exquisitely simple, sometimes elaborately and elegantly complex.

The near-perfection which the profession has now attained and which the public has come to take for granted, is seldom accomplished by the photographer alone. He or she almost always relies on the back-up skill of two other professionals who are, alas, usually anonymous. They are the props stylist and the food stylist, without whose talents the photograph would be most unlikely to reach the printed page.

Women dominate both fields. "You can always recognize a props stylist," says Antonia Gaunt, one of London's leading practitioners, "because she is harassed, in a hurry and weighed down with bulky bundles." It is her job, after consultation with the art director or the photographer, or both, to choose and gather all the bits and pieces that give the picture atmosphere—the background and accessories, the cutlery and glassware, the linen and flowers.

She must be inventive and imaginative. She must also have a fairly thick skin. Having visualized the end result and assembled all the objects that help make the photograph beautiful, she simply delivers it to the studio and walks away, leaving the final realization of the concept in which she has figured so creatively entirely up to the person with the camera.

The food stylist, sometimes called the home economist, fares better. Pete Smith, one of the few men in the business, an Australian transplanted to London and a former chef, starts work long before the shoot begins and stays with it to the very end. He selects and buys all the food (nothing short of perfect will do); cooks it in the studio (to ensure against catastrophe, he always prepares at least two of everything) and arranges it, hot and bubbling, or cold and ice-dewed, on the set.

He doesn't worry about seasoning when he cooks for the camera, but everything else must be as real and unsullied as though the dish were to be served in a four-star restaurant. Or almost everything. He and most of his colleagues permit themselves a few small subterfuges. He will artificially brown a chicken with caramel glaze and tighten its skin with dishwashing detergent. He will also use a disproportionate amount of gelatine in aspics—"Enough to set a small lake"—to keep them from disintegrating under hot studio lights. But ice creams and sorbets are completely unadulterated, merely packed round with dry ice to stop them melting before the moment when the shutter actually clicks.

The men and women whose photographs appear in *Food in Focus* warmly credit the stylists on whom their reputations to a large degree depend. They are themselves an individualistic lot whose responses to the questions that were put to them for this book varied enormously. Some went into detailed technical explanations of the way they work. Others were far more concerned with aesthetics and inspiration. Asked to select two of their own favourite pictures for inclusion here, most chose shots which they had made for themselves and which expressed their own penchants and proclivities, rather than shots which they had been commissioned to produce.

All share in the genuine talent which they bring to their profession, and in the creation of photographs that glow and tantalize. Participants in a newborn and exciting contemporary genre, they are the true inheritors of the still-life masters of the past.

PETER BAUMGARTNER

PETER BAUMGARTNER considers himself a designer and an illustrator with a camera.

The more control he has over a project the more successful he feels that he can be. He specializes, therefore, in studio set-ups like the two shown here, where he is subject neither to the vagaries of weather nor to the temperament of human models. These two photographs are, nevertheless, utterly unlike each other—the cheese an example of precision-built graphic composition, and the still life with shrimp a moody atmospheric image.

His work embraces still lifes, interiors and special effects. He attributes his penchant for graphic effects to his training in Berne, Switzerland, first at an art school and later as an apprentice in a graphic design studio. His photography is self-taught and he owes much, he says, to the influence of Hiro, Bert Stern and Robert Freson.

He enjoys assembling props and building his own sets. He also does a lot of his own food styling, so long as it doesn't interfere with tight shooting schedules.

He photographed the cheese (overleaf) for the front and back covers of a promotional booklet published by the Dairy Bureau of Canada, for which he also produced thirteen inside photographs illustrating recipes. The marketing strategy was to give cheese a "light and healthy look" and the graphic approach was decided upon during several creative meetings between the photographer, the client and Marina Brunelle, the art director of McKim Advertising, the Dairy Bureau's advertising agency.

The "checker-board" tile background was used as a unifying motif throughout. Different colour schemes were chosen for each shot, to complement such dishes as salmon mini-quiches, cheddar cheese soup and lasagne pinwheels, all of which were prepared in his studio by Sharon Dale, a Toronto home economist.

Peter Baumgartner had no layouts in advance. He worked with space lineals, tracings that indicated the positions of the text "window" and the client's logo. The cover, like all the other pictures in the series, was composed on the set, with his two assistants moving components about like chess pieces, while he tested and retested with "lots and lots of large-format Polaroids." He had a substantial budget, which gave him plenty of time and a generous selection of accessories with which to experiment. Decisions were made jointly by Baumgartner and the art director.

Stand-in food was used during the testing stages, the pieces of cheese cut to the exact size of those eventually to be photographed, which stood waiting in the refrigerator, in air-tight wrapping. Throughout the sequence, the food was lightly touched up with oil where necessary, and all of the fruit and some of the vegetables were soaked in "fresh fruit" preservative or lemon juice. Everything was photographed cold (as was the case, too, in the shrimp shot).

The main light source was a diffused side-light, to give texture to the food, and he created shadows with a large overhead diffuser, three feet by six feet (0.9 by 1.8m), at half power. He shot with a wide-angle lens and two Broncolor studio flashes and made fifteen exposures. The cover, quite separate from the recipe photographs, took two days after the background had been set up; preparation and co-ordination for the entire series required seven days.

For Peter Baumgartner's second photograph, an illustration for a promotion sheet to push the sales of Argentine shrimp, his budget was tight and the assignment demanding—to illustrate four recipes on a single page and to create a South American atmosphere. He made a rough sketch, which was approved by Ella Feig, the art director of the advertising agency (Allard-SMW), and composition again took place largely on the set with stand-in dishes. The real dishes, prepared by Vivian Merrill, a Montreal home economist, waited in the wings for the actual shoot.

The sense of perspective came from "playing with the size of the elements" (a very large dish in the foreground, for example), by diminishing the light towards the back and by using a wide-angle lens. His light sources were the same as for the cheese. He and one assistant spent a half day preparing and a full day setting up and shooting.

PETER BAUMGARTNER

PETER BAUMGARTNER
1905 rue William
Montreal
Quebec H3J 1R7
Canada

Works mostly through advertising agencies for clients in the food and beverage industries, including the Dairy Bureau of Canada, Kraft, Catelli, Schenley and Seagrams.

Awards

Publicité Club de Montreal: Coq d'Or
Art Directors Club of Toronto: Silver
 Award
New York Art Directors Club: Merit
 Award
Clio Awards: International Print
Marketing Awards: Certificate of
 Excellence

TECHNICAL DETAILS

Shrimp
CAMERA: Sinar
FILM: Kodak Ektachrome 64
APERTURE: f32–45
LIGHT SOURCE: Broncolor studio flash

Cheese
CAMERA: Sinar
FILM: Kodak Ektachrome 64
APERTURE: f22
LIGHT SOURCE: Broncolor studio flash

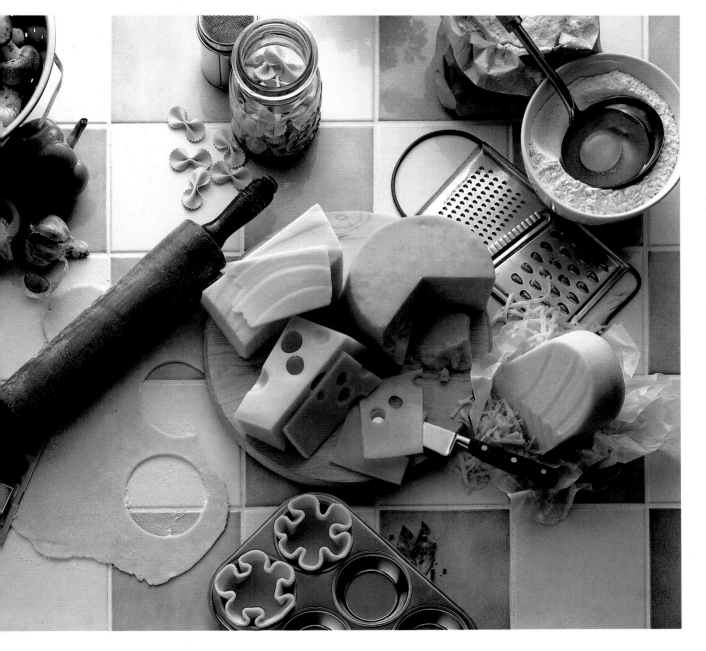

ANTHONY BLAKE

ANTHONY BLAKE's work has been influenced by most of the world's top photographers at various times. His "love of observation" and his love of food in all its forms have been even more important. Japanese cooking may be his favourite, but he can think of none that he dislikes. He is himself enthusiastic about cooking and he regularly prepares food for his own photographs. "Unless a dish looks as though you can take it out of the picture and eat it," he says, "the photograph has failed."

He says fervently that photography is not just his profession: "It has become a part of me, and it makes a perfect combination with my love of food and the natural world." The word "natural" is the cornerstone of his creed. He will never, under any circumstances, adulterate food or use phoney substitutes to placate the camera.

Anthony Blake's photographic travels have taken him to remote and romantic places—the Far East, the Pacific, both Americas, the Caribbean, the Mediterranean and almost all of Europe. His photograph of an outdoor supper in southwest France (overleaf), which was taken for an advertising poster, is typical of the truthful shooting he does wherever he goes.

He and Jillie Faraday, his Paris-based stylist, bought the props and the fresh foods from local markets and found the chairs and the weather-beaten table standing outdoors near the site that they had chosen. Anthony Blake likes to work in this way on location and to structure his compositions around discoveries made serendipitously, rather than arriving with hard and fast (often strait-jacketing) preconceptions. On the other hand, he may sketch a visualization in advance, usually for studio work where he is in complete control. Once he gets started, however, he is likely to toss the sketch aside and design his picture as he works.

For this assignment, the agency had given him a simple layout, indicating in general the space he would have to fill. All the creative decisions were left to him. It took him, his stylist and his assistant two days, starting at eight-thirty in the morning, to assemble, compose and shoot twenty to twenty-five shots in large format, plus additional 35mms.

He mounted a generator in the field and combined flash with natural daylight: "I just waited for the right moment," he says, "and prayed a lot that the weather wouldn't change." Fortunately, it did not, and the only problems were shooing the flies away and making constant quick changes from the ready supply of fresh foods and cold beer.

He produced his second photograph, an illustration for the back cover of a book called *Far Eastern Vegetarian Cooking*, in his London studio with the aid of an assistant. The illustration was also used inside the book. It is utterly simple, in keeping with its oriental subject, a Japanese salad of sliced cucumber and dried mushrooms. Margaret Leeming and May Huang Man-hui, the joint authors, prepared the salad and the sesame sauce that went with it in Blake's studio. He himself, with their help, assembled the props. He shot at dusk, using available light and Elinchrom flash. It took him about an hour and a half to set up and make twenty 35mm exposures. He had spent the earlier part of the day on other photographs for the same book.

Anthony Blake learned the craft of photography in the Royal Air Force and developed the art through working for magazines. His decision to specialize in photographing food, with the emphasis on its natural beauty, was almost inevitable, for in his youth he spent ten years on a dairy farm. There he learned to understand the feel of the earth, to savour country smells, churn butter by hand

Today most of his food photographs are taken to illustrate books. In addition, he does general reportage, travel features and corporate advertising. In recent years, he has put an increasing amount of time and effort into his photographic library, which contains more than 50,000 pictures, mostly of food or food-related subjects from all over the world—"Everything from the soil to the table." It also includes numerous seascapes and landscapes. Until the autumn of 1987, it was all his own work, but he has now invited other photographers to contribute.

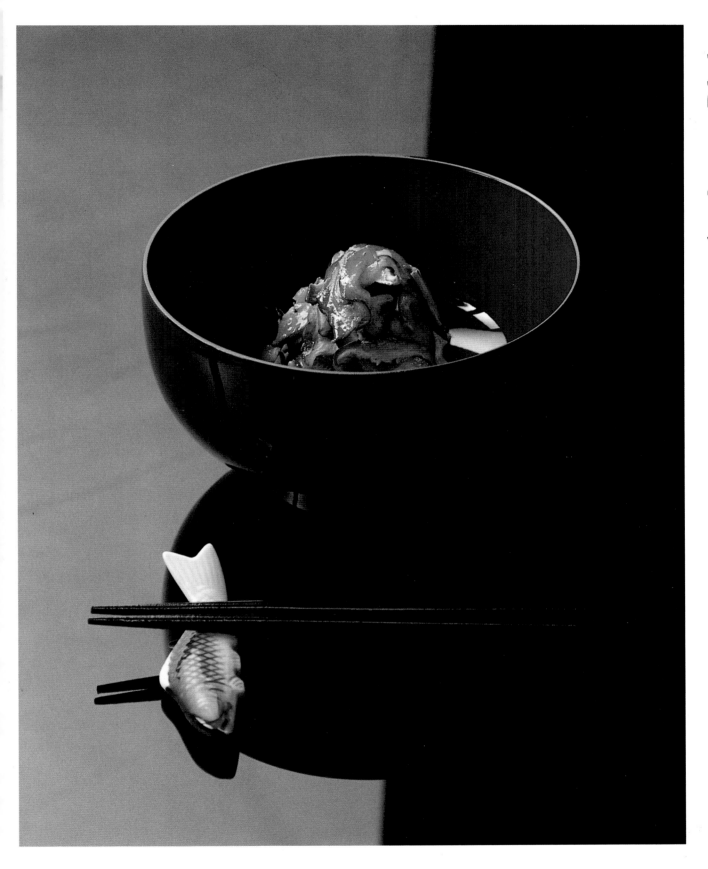

ANTHONY BLAKE

ANTHONY BLAKE
54 Hill Rise
Richmond
Surrey TW10 6UB
United Kingdom

Major Publications

Books:

Far Eastern Vegetarian Cooking
(Margaret Leeming and May Huang
Man-hui), Columbus Books, 1985

The Great Chefs of France, Mitchell
Beazley, London, 1978; Harry N.
Abrams, New York, 1978

New Classic Cuisine (A. Roux),
Macdonald, London, 1983; Barron's,
New York, 1984

Perrier menu guides

Reader's Digest menu guides:
French, Italian, Indian, Chinese.

The Roux Brothers on Patisserie (M.
Roux), Macdonald, London, 1986;
Prentice-Hall, New York, 1986

The Sauce Book (P. Aris), Century,
London, 1984; McGraw-Hill, New
York, 1984

Time-Life Foods of the World series:
The Cooking of the British Isles (Adrian
Bailey), 1969
American Cooking: Creole & Acadian
(Peter S. Feibleman), 1971
American Cooking: Southern Style
(Eugene Walter), 1971
*Cookery of the South Pacific and
Southeast Asia*

The Times Calendar Cookbook (Katie
Stewart), Hamlyn, London, 1975

Contributes regularly to many
magazines, including *Travel & Leisure*
and *Life*.

Awards

Design & Art Directors: various awards

Award for *The Great Chefs of France*
(black and white)

Kodak award in Paris for French perfume
advertising

Audio-visual presentation for the
seventy-fifth anniversary of the
Institute of British Photography

Associate of the Royal Photographic
Society

Associate of Incorporated
Photographers

Former chairman of the Association of
Fashion Advertising and Editorial
Photographers

TECHNICAL DETAILS

Japanese salad
CAMERA: Leica
FILM: Kodachrome 25
APERTURE: *f*4.5–6
LIGHT SOURCE: Elinchrom flash and daylight

Outdoor supper
CAMERA: Sinar
FILM: Kodak Ektachrome 64, pushed 2 stops
APERTURE: *f*4.5
SPEED: 1/4 second
LIGHT SOURCE: Elinchrom flash and daylight;
generators on location

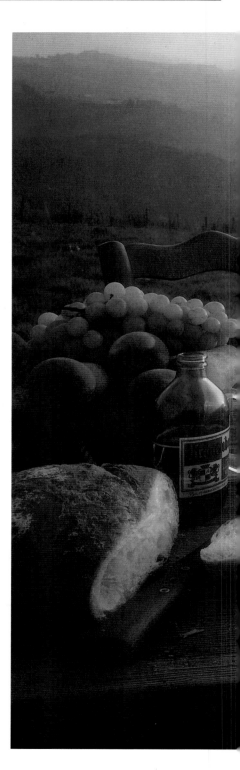

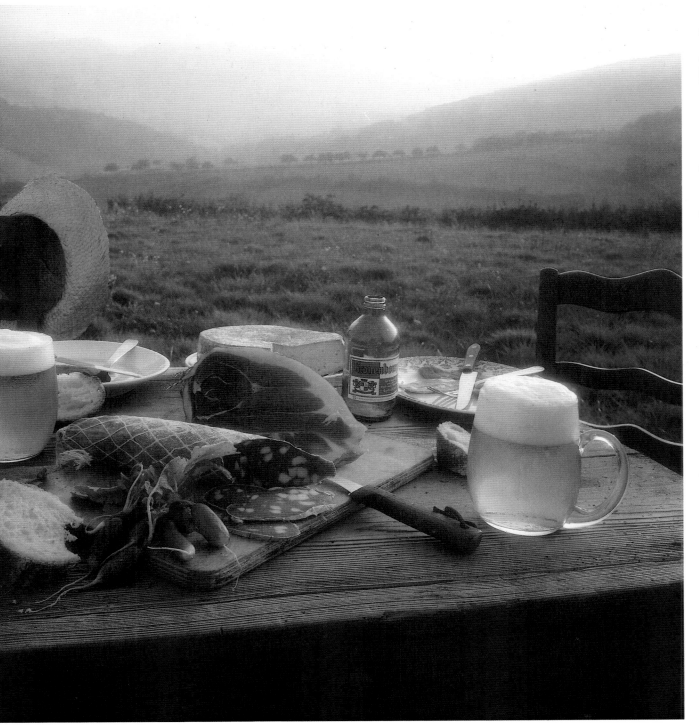

MICHAEL BOYS

MICHAEL BOYS is not only a distinguished food photographer. He is also known as "the calendar king" and has no peer in the art of portraying the female nude. He sees no contradiction in this—quite the contrary. "With both subjects you're appealing to basic carnal desires," he says. "And you're faced with similar problems. How to devise the most appetizing pose, and how best—by arranging the meat in the right way on the dish, for example—to stimulate the palate." He coined the word "gastroporn" for today's sensually provocative, deliberately titillating cook books.

He has been taking pictures professionally for some thirty-five years, photographing gardens and decor as well as delectable girls and food. But he still tackles assignments in what he describes as an "untrained" and "amateurish" way. He says, "I use my camera as a sort of net, fishing around until I get what I want." He calls this "a relatively chancy approach" but, as the examples show, it has remarkably *un*chancy results.

Two fellow photographers have strongly influenced his work, Anthony Blake, whom he considers probably today's best all-round food photographer, and the multi-faceted Robert Freson.

Boys enjoys cooking, especially fresh vegetables that he grows himself. Recently he has dished up a mousse of courgettes with anchovy sauce, a mousse of beets with bacon sauce, and leeks vinaigrette. Given the right mood and the right company, he likes cooking fresh-caught fish over a driftwood fire on a beach.

He is rarely without a camera and when he has concocted a succulent delicacy, he often finds himself struggling with a difficult decision: "Do I pick up the knife and fork—or the Nikon?"

Since his much-admired bare beauties would not have fitted easily into the format of this book, he has chosen two pictures which he feels are slightly out of the mainstream of food photography.

The rabbit with the twinkling nose, who enlivened the cover of *A la carte* magazine, is likely to win, paws-down, as the most offbeat cover girl of the decade. He photographed her, wistfully eyeing the crisply tantalizing salad, in his London studio. She is a professional model and he says she behaved perfectly, except: "She had a penchant for my salad dressing, a blend of white wine, sugar and walnut oil."

The photograph was taken by flash, at $1/500$ second, and the rabbit was then permitted to work her way through the slot and demolish the melange of greens. He recorded this foray as well. The denouement was pictured on the inside cover of the magazine.

His second choice (overleaf), the pastry frying pan filled with vegetables, was part of an eight-page feature in *A la carte* (October/November 1984).

Michael Boys was briefed for both photographs by Jenny Greene, then *A la carte*'s editor. Each shot involved a props stylist, an assistant and a set-builder. For the first, there was also a home economist in the studio, and for the second, the professional chef who was the subject of the feature. For both, Boys decided on the props and the stylist assembled them.

Antony Worrall-Thompson, the chef and owner of Ménage à Trois, a small, chic London restaurant, made the pan of phyllo pastry and stir-fried in butter the garden vegetables that went inside it. To enhance the sense of distance, Boys had all the objects on the set built in exaggerated diminishing perspective.

He spent half a day on the rabbit photograph and an eighth of a day—for this was only one part of an eight-page story—on the frying pan.

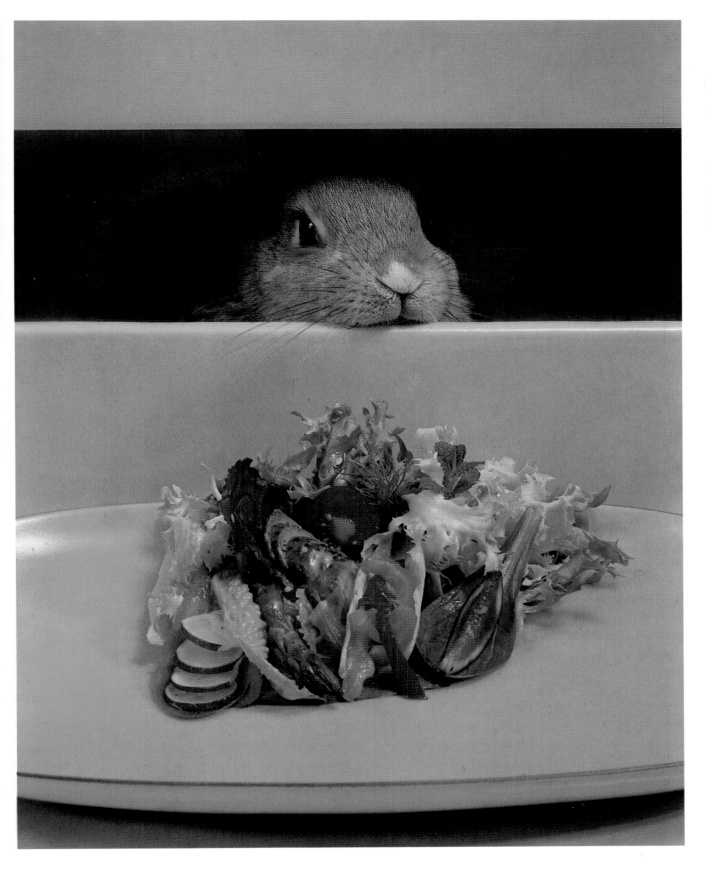

MICHAEL BOYS

MICHAEL BOYS
17 Victoria Grove
London W8
United Kingdom

Major Publications

Books on decoration, nude
photography, outdoor eating, including:
*Recipes from Le Manoir Aux Quat'
 Saisons* (Raymond Blanc),
 Macdonald Orbis, London, 1987
The Summer Cook Book (Nanette
 Newman), Hamlyn, London, 1986

TECHNICAL DETAILS

Rabbit
CAMERA: Bronica ETR
FILM: Kodak Ektachrome 64
APERTURE: f16
SPEED: $^1/_{500}$ second
LIGHT SOURCE: Moonlight umbrella flash
 with polarizing and colour correction
 filters on camera

Frying pan
CAMERA: Bronica ETR
FILM: Kodak Ektachrome 50, tungsten
balanced
APERTURE: f16
SPEED: 4 seconds
LIGHT SOURCE: tungsten with warming up
 gels to catch ambient light. Corrected on
 camera with an 82A

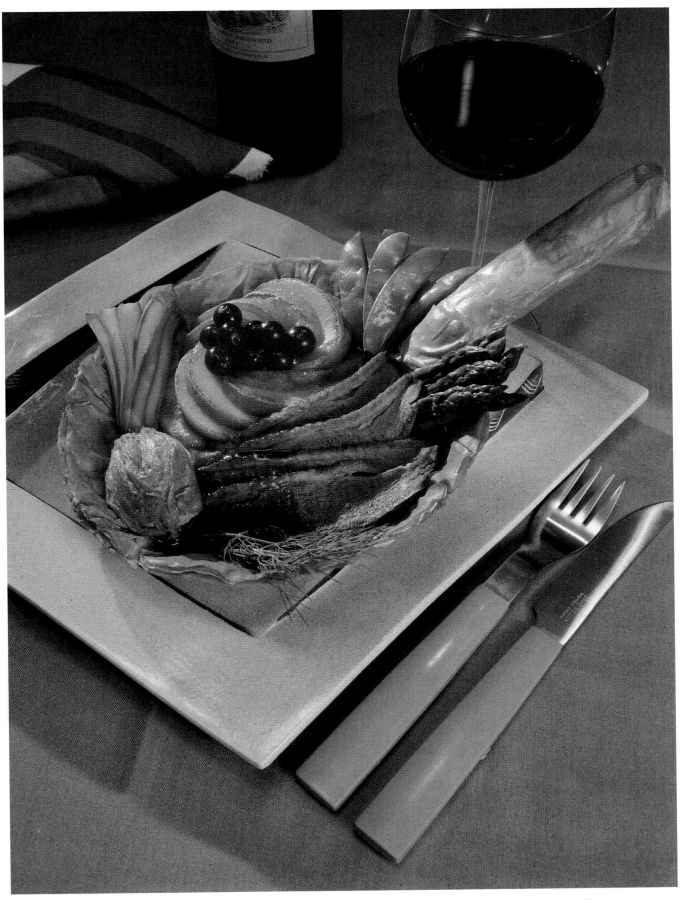

DESMOND BURDON

DESMOND BURDON emigrated from Ireland to study photography in London. He left his college, so he says, "greener than the Emerald Isle itself," and was lucky enough to stumble into a job as an assistant to "a really great photographer, Bernard Phillips." He has been inspired more indirectly by the dramatically beautiful still-life photographs of François Gillet. He believes that his own style is still taking shape and he cheerfully confesses to making technical mistakes that sometimes turn into technical triumphs.

He was pleased that an article in the *British Journal of Photography* praised him for producing "images whose richness of detail and tone convey flattering ideas about a project," but he said that every advertising photographer does the same. "That's what we're paid for," he says, "to flatter anything we shoot—frilly silk underwear, a teapot, a glass of beer."

Burdon uses a variety of techniques to achieve this photographic flattery—simple diffusion; combining black and white and colour in a single shot; overlaying a transparency with a monochrome tint, or incorporating a finished print in a new exposure. He has no qualms about retouching a picture to drive its message home. He almost always uses large-format film which provide a large, manageable palette on which to exercise his ingenuity.

The photograph of mushroom soup (overleaf), one of sixteen shots that he took for Lever Brothers to use on packets of dried soup, is more straightforward than much of his work. He operated to a tight commercial brief with instructions to use more or less the same format for all sixteen so that when the packets were lined up on a supermarket shelf, the branding would be strong, clear and immediate. Shooting within the constraints imposed by packaging, he was to create a theme and a mood.

He used no tricks to dress up the soups. They are the real thing, with emphasis on the ingredients. But he did cheat a bit on the lighting. He made two exposures for each and shot the background and the foreground separately so that the light from one would not spill over on to the other. He used tungsten and soft filters, and gave the foreground twelve seconds and the hand-painted background a minute and a half.

He and his assistant worked rapidly through the series (he had no other help). They spent about a day and a half on each set-up to achieve eight transparencies for each. The client's art director looked in from time to time, Burdon says, "to crack the whip, make sure we were going to meet the deadline, and to murmur, 'Lovely, lovely', and depart."

The photograph of the orange and lemon, which was a cover for *A la carte* magazine, is far more typical of his offbeat style. It was the first editorial shot he had ever done (he has since done a second, also for *A la carte*) and in it trick is heaped upon trick.

He began by shooting the entire still life both in colour and in black and white. He then made a large black-and-white print and put a blue wash over everything except the rim of the fruit bowl, left alone to bring out the silvery effect, and the orange and the lemon. The fruit was hand-tinted to make the colours more vivid. The two photographs were eventually combined into one and retouched to obliterate any "seams" and to smooth out the tones.

It was a finicky, time-consuming effort, involving two days of preparation and one day of shooting. Ian Findley, *A la carte*'s art director, Paula Lovell, a props stylist, Nigel Slater, a food stylist, and a photographic assistant, a photo-comper, tinter and retoucher all took part. Desmond Burdon made twelve black-and-white exposures, four colour exposures, numerous black-and-white prints, and sixteen colour dupes. "An expensive hassle all in all," he says.

He much prefers advertising assignments to editorial because the budgets are far less cramping. "Admittedly, you don't often get paid to go all dreamy and moody," he says. "A client will often ask you to water down an idea to make the product more visible, but once agreed, he will usually give you a free hand to get on with it."

Burdon has no great passion for particular foods except for chocolate, but he likes to cook almost anything.

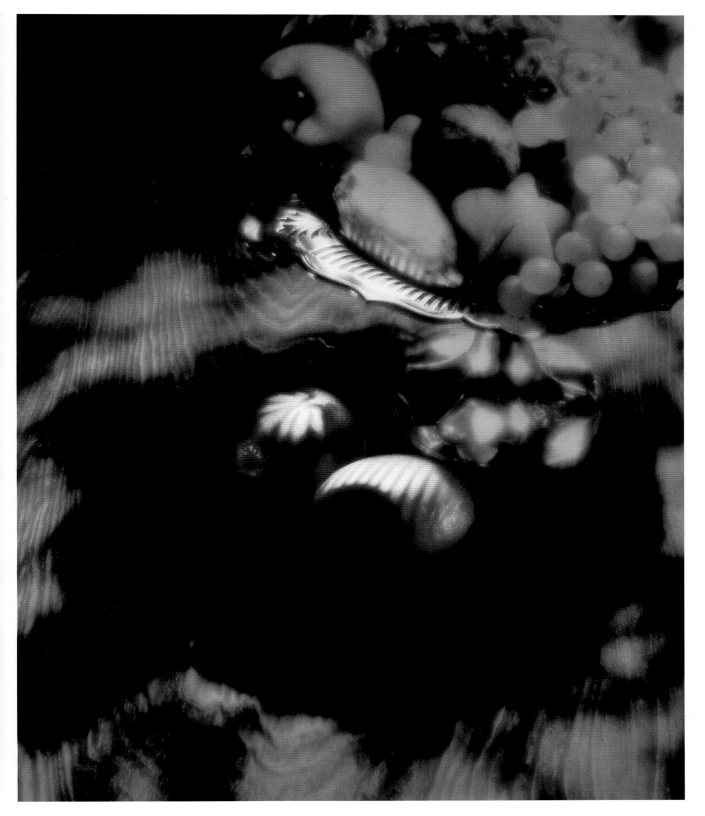

Desmond Burdon

DESMOND BURDON

DESMOND BURDON
57 Farringdon Road
London EC1
United Kingdom

Major Publications

Work appears in a great variety of
publications, with advertising shots
done for agencies.

TECHNICAL DETAILS

Orange and lemon
CAMERA: Sinar
FILM: Kodak Ektachrome 50
APERTURE: f64
SPEED: multiple
LIGHT SOURCE: tungsten lights with soft
 filters

Mushroom soup
CAMERA: Sinar
FILM: Kodak Ektachrome 50
APERTURE: f64
SPEED: foreground 12 seconds, background
 90 seconds
LIGHT SOURCE: tungsten lights with soft
 filters

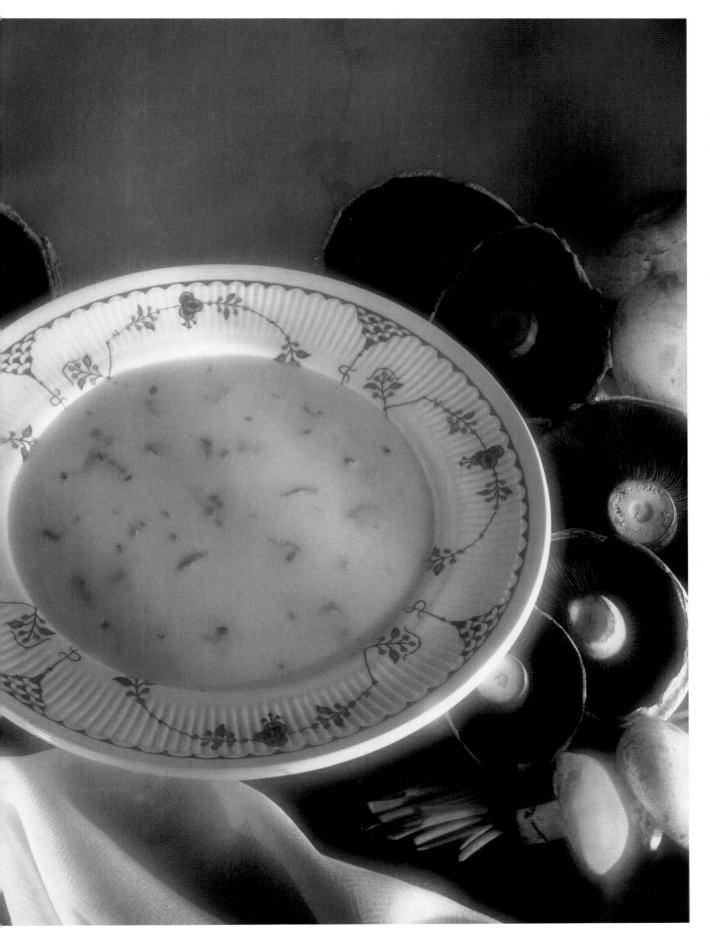

MARTIN CHAFFER

MARTIN CHAFFER once dreamed of becoming a restaurateur and spent several years in the business. He says he is a good cook—"When I can keep my wife out of the kitchen"—and will try anything except desserts and pastries, but "Never to set before the camera." He gets creative satisfaction both from cooking and from taking pictures. "To combine the two," he feels, "would be exhausting." In eating, too, he will try anything "except hundred-year-old eggs and a particularly vile Norwegian cheese."

His career began in photo-journalism—he was attached to the Black Star Agency—and he is a great admirer of Henri Cartier-Bresson. "Having moved into studio work without any formal photographic education," he says, "I find I treat every job as a stimulating new experience."

He chose his photograph of fish pâté not only because he himself likes it, but because Anton Mosimann, the distinguished chef of London's Dorchester Hotel, pointed it out in a recent article he wrote as the kind of clear, cool, simple food picture that he admires. It appeared on the cover of a Hotpoint brochure and was designed by Legon Bloomfield, the advertising agency. Chaffer's brief from David Legon, the art director, was to create an appetizing shot that suggested up-market cuisine.

He began by photographing a pâté that had been commissioned from a well-known London chef. As the team eventually discovered, it tasted quite delicious, but looked too pale and bland to make a good photographic subject. They decided instead to make their own with highly visible ingredients— salmon, seafood and vegetable pâté set in layers of aspic. "It's the transparency of the aspic," says Chaffer, "that gives the instant visual suggestion of delicacy."

There was another hitch as well: "The carefully blended sauce congealed and looked awful," Chaffer said. A second was conjured up—a mixture of tomato soup and gelatine which set solid and still looked perfect three days later. The pink marble background, the thin porcelain plate, the translucent table napkin and the straw-coloured wine all contributed to the delicacy of the mood.

To establish a sense of natural daylight, Martin Chaffer used a single diffused flash-head with white reflectors all round. He worked with two assistants, the art director, Hilary Green, a stylist, and Lesley Sendall, a home economist. Once the food had been redesigned, the shoot took two days and he made six large-format exposures.

His photograph of a country kitchen (overleaf) was taken for a Marks & Spencer brochure featuring cookware, and it was in every way more complex. He says that he was given a free hand on this one: "So we went to town on atmosphere." The set is based on his own farmhouse kitchen in the Dordogne, and building it took two teams—one to do the general construction and the other to carve the "stone" fireplace out of polystyrene and to paint both the fireplace and the "thick" walls so that they looked convincingly timeworn.

Hilary Green was again the stylist in charge of props and Joan Halliday, the home economist, prepared all the food in the studio kitchen. The chicken was slightly undercooked to keep it firm (this is usually done in food photography) and it was artificially browned with a light brushing of caramel. Everything else remained exactly as it was when cooked.

The smoke in the fireplace was produced with a bee-gun—the weapon that keepers of hives use to stun angry bees. This, unfortunately, wafted fine dust over the set, and all the surfaces had to be wiped off between shots, which was a nuisance. Chaffer made some thirty shots altogether, to accommodate various exposures for the flames in the fire and the fog effect through the window. He spotlit the separate features with tungsten. Despite all the complications, the entire job, including the building of the set, took only three days.

The kitchen photograph is more typical of Chaffer's style than is his pâté shot, for he specializes in room settings, chiefly for advertising brochures and publicity material. But he enjoys branching out into other fields, especially into food.

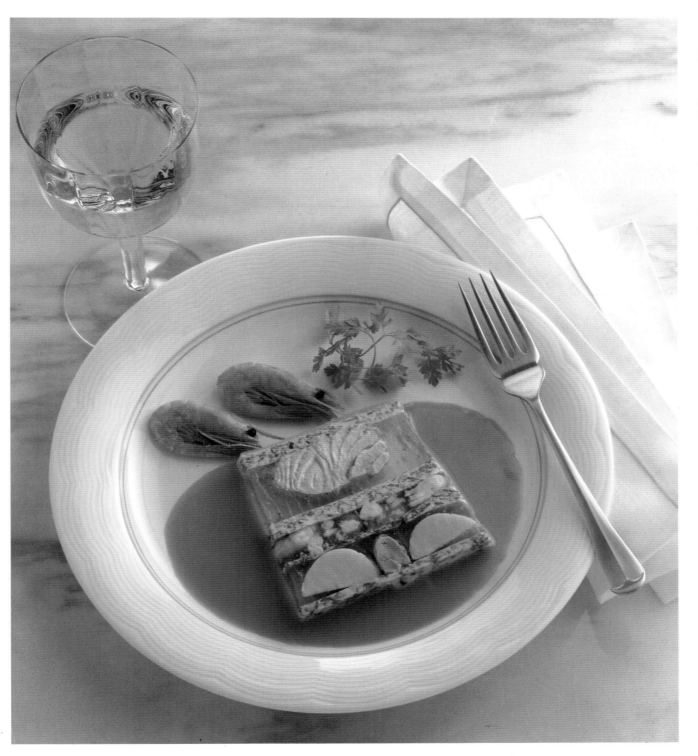

MARTIN CHAFFER

MARTIN CHAFFER
Battersea Park Studio
2 Shuttleworth Road
London SW11 3EA
United Kingdom

Work appears almost entirely in brochures and publicity material, mostly without photographic credit.

TECHNICAL DETAILS

Fish pâté
CAMERA: Sinar P
FILM: Fujichrome 50
APERTURE: *f*22
LIGHT SOURCE: Strobe Equipment single diffused flash-head with white reflectors all round

Country kitchen
CAMERA: Sinar P
FILM: Kodak Ektachrome 50
APERTURE: *f*32
LIGHT SOURCE: tungsten lights to spotlight various features; separate exposure for the fire

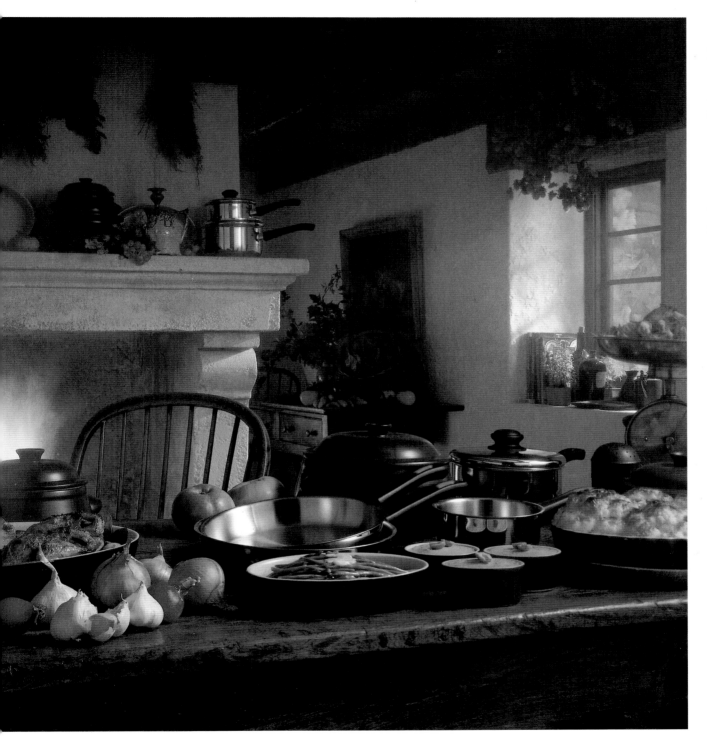

PAUL CHAUNCEY

PAUL CHAUNCEY by no means confines himself to shooting food. "I photograph what needs to be photographed," he says. "I create images for commercial use, whether for annual reports, labels or magazines. My job is to help my clients promote their products—anything from a 79-cent taco to a 25,000 dollar diamong ring."

He is entirely self-taught. Lighting and its magic in building imagery fascinate him more than any other aspect of photography. Food delights him and he enjoys even the simplest—a peanut butter and jelly sandwich or a chocolate chip cookie.

He himself doesn't even try to cook, except what he calls his "gourmet cinnamon toast." He never has to. "I'm lucky in life and in love," he says, "and I married a woman who cooks up a storm. If it weren't for Michele in the cooking department, I would be in deep water."

He dreamed up his juicy sizzling steak shot because he had never seen a photograph of cooking meat that looked realistic to him. "They always seemed too mellow," he says, "never violent enough." He built the set from scratch. The iron grill and the painted lava rocks were scaled both in size and perspective to make the huge two-pound porterhouse steak seem even more imposing. And the fire, the smoke and the grease were all real.

"That meant that we were asking for trouble," he says. He and Michele, who does all his food preparation and styling, ran the risk not only of shrivelling the meat but of starting an actual blaze in the studio. They took five separate exposures and each time they ignited the fire with lighter fluid in one spot, took a shot, extinguished the fire, and moved on to a new spot to ignite it again, thus gradually building the entire edifice of leaping flames.

They used a hand-held heating element to create the sizzle, a risk because it might also have overcooked and parched the meat. Luckily, that didn't happen. When the steak looked spitting hot, the flash was exposed and the smoke was blown in simultaneously. The smoke, which was chemically produced, caused problems of its own. The fumes were noxious and corrosive and they blew about uncontrollably. To create the burn marks the Chaunceys seared the steak with a red-hot metal rod, like a branding iron. After all that, the signature scrawled high in neon was easy.

The Chaunceys worked on the image for three days. At each session they added another touch—a little more smoke, for example, or a higher flame. The actual photography took only two and a half hours. Paul Chauncey shot about thirty-six sheets of film, each with three exposures. There were no lab tricks: it was simply a matter of patiently and repeatedly opening and closing the lens.

The photograph of the sandwich (overleaf), was "an absolute doddle" by comparison. Paul Chauncey produced it during one long eighteen-hour working day, to show to a deli-meat client for whom he was preparing a promotion. Chauncey's objective was to create a colourful summer lunch in a cool-looking atmosphere. He achieved this with "regressive blues played against receptive reds and yellows, on good old basic graphic-design principles."

He placed a blue gel behind the bamboo screen, which was itself backed with seamless black paper, and positioned a small gold reflector behind the iced tea to produce the highlight. He exposed twelve sheets of Ektachrome 64 and four of Vericolor II, working quickly before the thin slices of meat began to curl and split in the heat of the Speedotron flash.

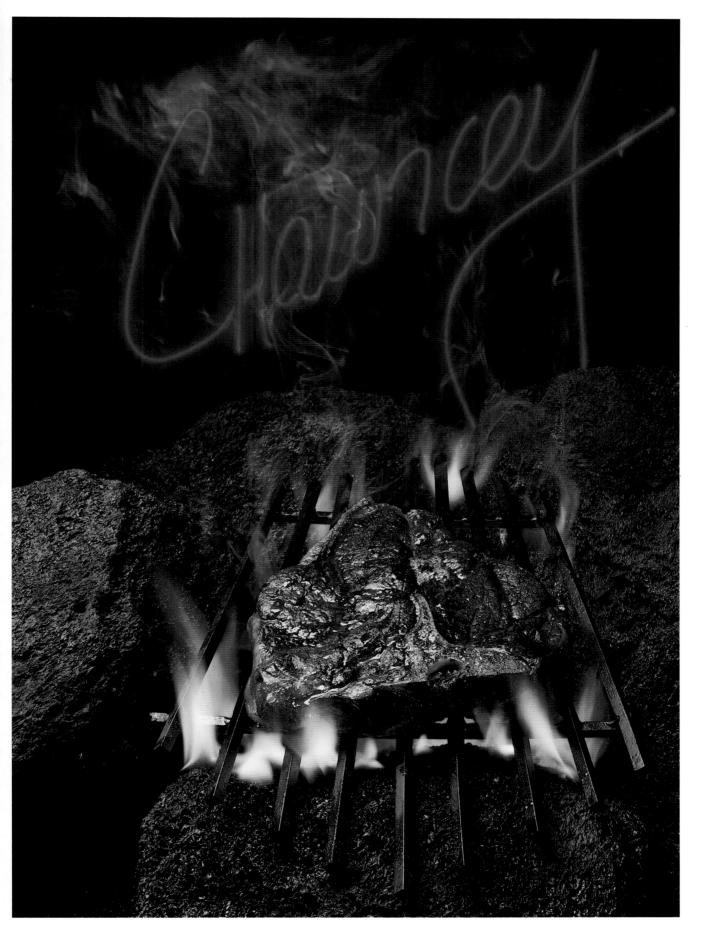

Paul Chauncey

PAUL CHAUNCEY

PAUL CHAUNCEY
388 N. Hydraulic
Wichita
Kansas 67214
United States

Work is used almost entirely in
advertising and for packaging.

Awards

Awards include Clios and, the greatest
award, the loyalty of his clients.

TECHNICAL DETAILS

Sizzling steak
CAMERA: Sinar
FILM: Kodak Ektachrome 64
APERTURE: f22 for numerous exposures
LIGHT SOURCE: Speedotron flash, flames,
 neon, yellow filter to eliminate blue in
 rock

Ham sandwich
CAMERA: Linhof
FILM: Kodak Ektachrome 64 and Vericolor II
APERTURE: f45
LIGHT SOURCE: Speedotron flash, gold
 reflector

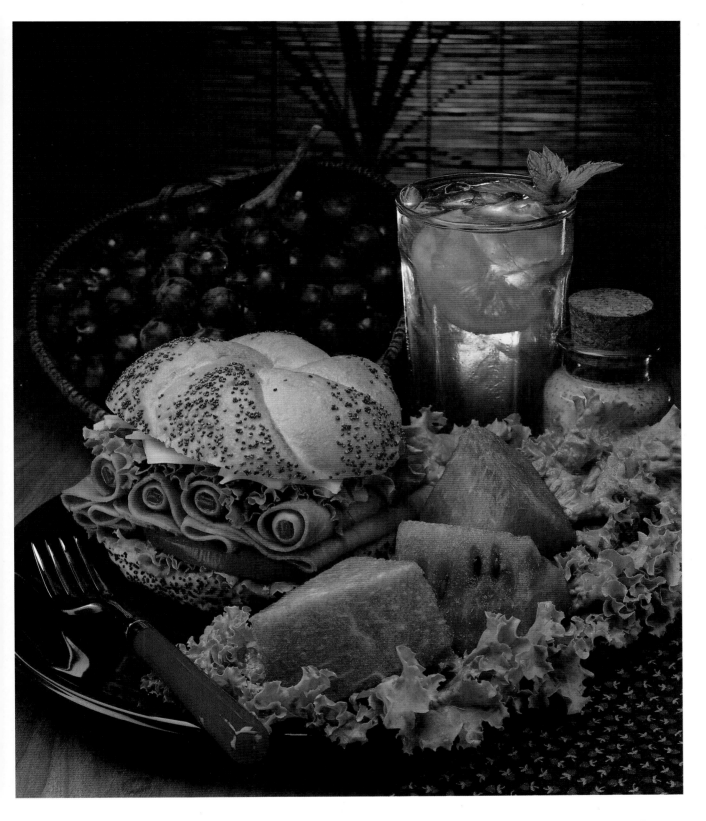

Paul Chauncey

WALT CHRYNWSKI

WALT CHRYNWSKI often makes advance sketches to work out angles and proportions, a skill that comes easily to him thanks to an art school training. He has a large reference library of great paintings. But his most important formative influence, dating from a time when he thought of photography only as a hobby, was the American landscape photographer Walker Evans, who imbued him with a love of the outdoors.

Landscape photography is still Chrynwski's hobby, although he makes his living in the studio, where he divides his time 60 per cent/40 per cent between editorial and commercial still lifes. "There is nothing wrong in taking short cuts," he says about his advertising assignments, "so long as you don't distort the product. That must always remain natural and unadulterated. Anything else in the picture can be made of stone." He will use acrylic cubes instead of ice cubes, for example, or create steam with chemical tablets, or use a low-calorie pressurized imitation whipped cream which will stand up to hot lights instead of the real thing which won't.

It was because Chrynwski enjoyed the look of food that he was impelled to begin to photograph it. He enjoys eating it too, but cooks "only with great difficulty." He would not dream of trying to prepare anything for professional use.

He has chosen two photographs which are so different that they might have been taken by two quite different people, the bread a classic still life, and the chocolate chip cookies (overleaf), an expression of high tech. He took both to please himself for inclusion in his portfolio.

The shot of the bread was directly inspired by *Pears and Melon*, a painting by the eighteenth-century Spanish artist, Luis Melandez, whose mood Chrynwski has accurately echoed with his dark tones and deep shadows. He used a warming filter and one single light overhead plus a fill near the camera position, and he placed cards between the main lights and some of the breads to keep certain areas dark. A tiny aperture (only *f*64 both for this and for the cookies) meant that he needed three or four flashes.

He had no assistance with either shot. He assembled the props himself and bought the breads from a local New York bakery. He toned down the high gloss on the egg-glazed, twisted *chaleh* in the foreground and the shine on one or two of the other loaves with a patent dulling spray to reduce reflections. After he had spent a little more than a day in preparation and a little less than a day in shooting, most of the breads were hard as rocks.

He shot a number of large-format Polaroids as he always does; when he is satisfied "that the image is 100 per cent," he exposes his Ektachrome— usually about ten sheets—in exactly the same way.

He made comparatively few tests for the bread, but a great many more— "easily over a dozen"—for the cookies, a photograph that was more demanding in every way. He mocked up the set in advance, playing with angles and proportions and using stand-in cookies. To guarantee perspective when it came to the actual shoot, he asked Cynthia Caldwell, the food stylist, to bake several sizes. He wanted a monster cookie four inches (10cm) in diameter as the dominant one on the spatula, but smaller ones, no more than half that size, to appear on the rack. (She baked about five dozen to produce seven that were perfect for the picture). He exaggerated the difference further by using a wide-angle lens and by tilting both the rack and the baking pan.

The set-up was on a piece of glass covered with frosted acetate, beneath which he shone two flash units to achieve the milky white background. A large bank above lit the rack, with its three cookies, and a small bank eighteen inches (45cm) square, to the left of the camera, lit the pan with its four cookies in the front.

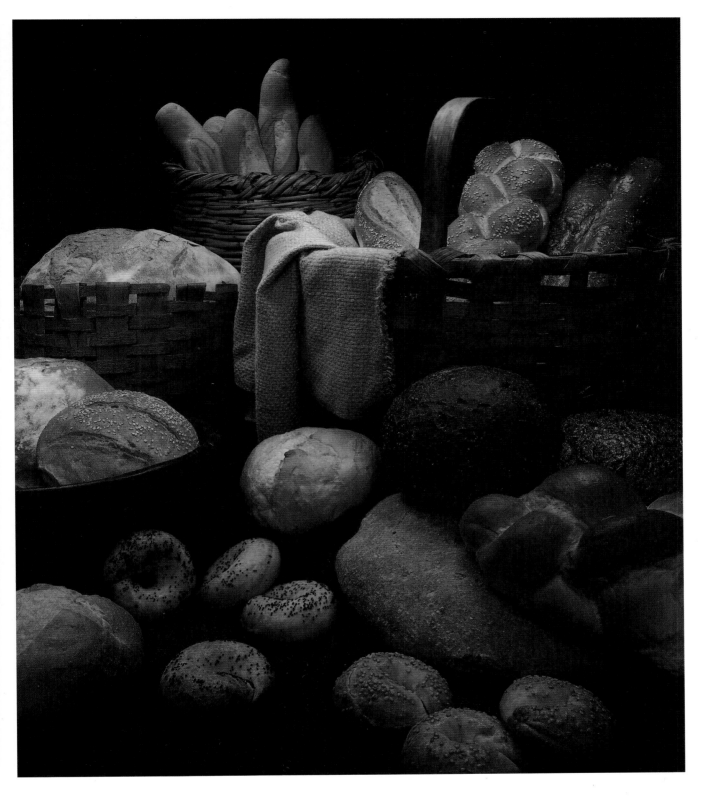

Walt Chrynwski

WALT CHRYNWSKI

WALT CHRYNWSKI
154 West 18th Street
New York
NY 10011
United States

Major Publications

Work appears in *Business Week*, *Food & Wine*, *Woman's Day* and other magazines and is published in books by Holt Rinehart & Winston and McGraw-Hill. His advertising clients include Chesebrough-Pond's, General Foods, Rémy Martin, Schenley, Scott Paper, Sunkist and Upjohn.

Awards

Art Directors Club: Distinctive Merit
 Award, 1986
Graphic Design USA: DESI Award, 1986

TECHNICAL DETAILS

Bread
CAMERA: Calumet
FILM: Kodak Ektachrome 64
APERTURE: *f*64
LIGHT SOURCE: single light overhead, fill
 near camera position

Cookies
CAMERA: Calumet
FILM: Kodak Ektachrome 64
APERTURE: *f*64
LIGHT SOURCE: 2 flash units underneath,
 large bank above for back of shot, small
 bank 18 inches (45cm) square to left of
 camera for foreground

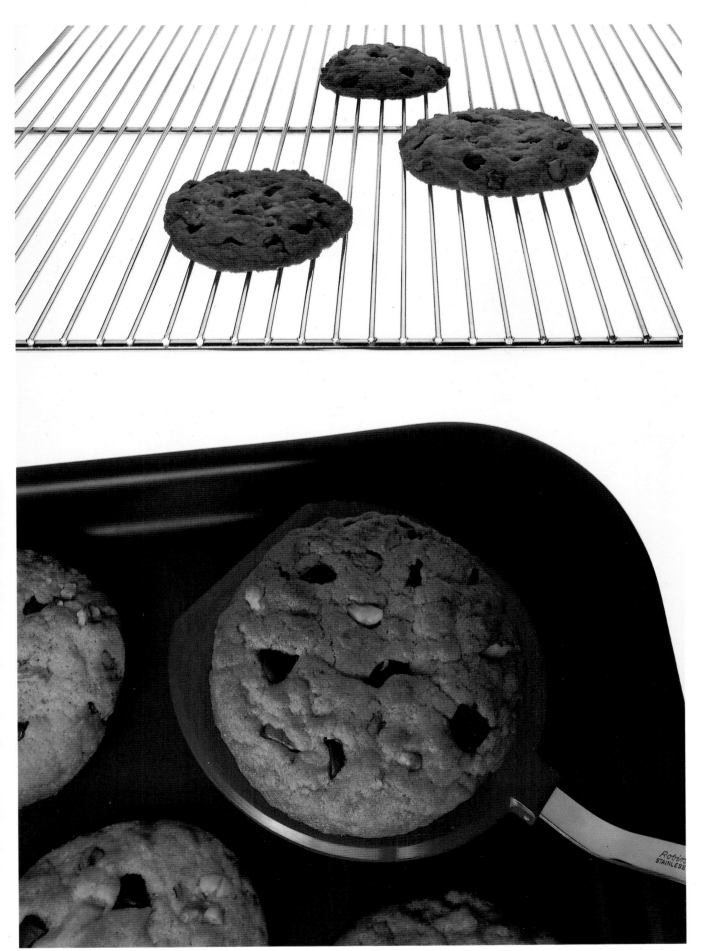

SKIP DEAN

SKIP DEAN has learned a great deal from paintings, from graphic design and from the study of the shape and texture of everyday objects. But the most important inspiration has come from the "many great art directors" with whom he has worked in Canada and the United States. And more than one good creative idea has come out of his own mistakes. "A mistake often takes me into an area where I normally wouldn't go," he says. "I come out knowing how to make a wrong a right."

He likes to cook—mostly seafood and salads—and he often photographs what he serves. He also carries a camera with him when he dines out, and whenever he sees a dish that he admires or a well-designed arrangement, he makes a record of it.

His goal always is to create a mood that complements the copy he is illustrating, and at the same time to provide a piece of art that tells an independent story, as does his photograph of everlasting syllabub. The tall, graceful glass has become an intrinsic part of a total composition that is far more interesting than the syllabub could possibly have been on its own.

He likes it because "It is more than just a shot demonstrating a particular recipe. It has a seasonal feeling with undertones of country charm." He often incorporates art objects—a vase, a piece of sculpture, a painting—into his photographs to establish a mood, as he has done here with the nineteenth-century lithograph that fills the background and sets a tone of amiable domesticity.

Dean shot this photograph for Canada's *Homemaker's Magazine* with the help of a bevy of experts: an assistant; Kate Bush, a well-known food stylist; a props stylist; Rod Della Vedova, the publisher's art director; and the client. "The best thing a photographer can do," he says, "is to get the best people with the best skills and the best energy—people who are going to bust their butts to make you look great." It took him and his high-powered team about eight hours to produce five exposures on large-format film. The main challenge was to "make the setting feel natural" and to achieve "an easy balance" between the various colours and hues.

The same team came together—and again produced five exposures in about eight hours—for his soup photograph (overleaf), which he took for the *Homemaker's Cookbook*. Because the soup, a vegetable broth garnished with walnuts, was (like the syllabub) not particularly interesting on its own, Skip Dean perked it up by having it ladled into a hand-painted bowl, which not only echoes dramatically the colours of the contents but is in its own right a lovely object. The composition in this case is entirely realistic, and satisfying to the photographer because of the contrasts between the soothing tones and the diverse textures; he achieved this by careful control of the lighting ratios. The vegetables were slightly undercooked to keep them looking firm, bright and crisp.

About 80 per cent of Dean's work is with food, both for editorial and advertising. He enjoys venturing into other fields, but feels that he must be fair to his clients: "They pay high fees," he says, "and they have the right to expect specialization." In any case, he finds food a particularly responsive subject. "Its natural beauty and shape lend themselves to the creative eye. Food has an incredible quality—a feeling of life within still life."

When he does move into other milieux, he applies the same techniques and disciplines as in his food photography, with the same aim of stimulating the taste buds—to make cigarettes or jewels, for instance, sensually appealing.

He seldom works on location, preferring the luxury of absolute control in his own well-stocked studio. So much food is prepared and photographed here that he could, he says, open a small supermarket with the soups, salads, meats, breads, pastas and so on that are left after shooting sessions. Instead he sends it to local charities.

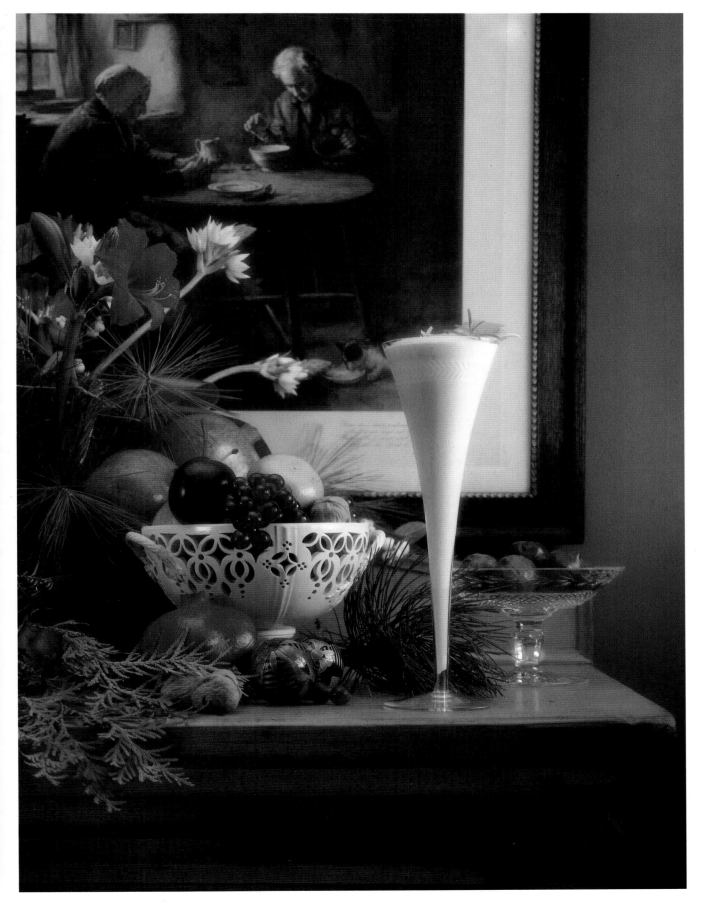

SKIP DEAN

SKIP DEAN
9 Davies Avenue, Suite 200
Toronto
Canada M4M 2A6

Major Publications

Books:
Bonnie Stern's Cuisinart Cookbook
Homemaker's Cookbook

Magazines:
Canadian Living
Creative Source
Duncan Hines
Homemaker's Magazine
Recipes Only
Toronto Globe & Mail
Toronto Life Magazine
Toronto Magazine
Vision Magazine

Awards

New York Art Directors Club Awards
Creativity Award

TECHNICAL DETAILS

Everlasting syllabub
CAMERA: Sinar
FILM: Fujichrome 100
APERTURE: *f*32–45
LIGHT SOURCE: Speedotron studio flash with
 plume wafer bank-lights

Vegetable broth with walnuts
CAMERA: Sinar
FILM: Fujichrome 100
APERTURE: *f*32–45
LIGHT SOURCE: Speedotron studio flash with
 plume wafer bank-lights

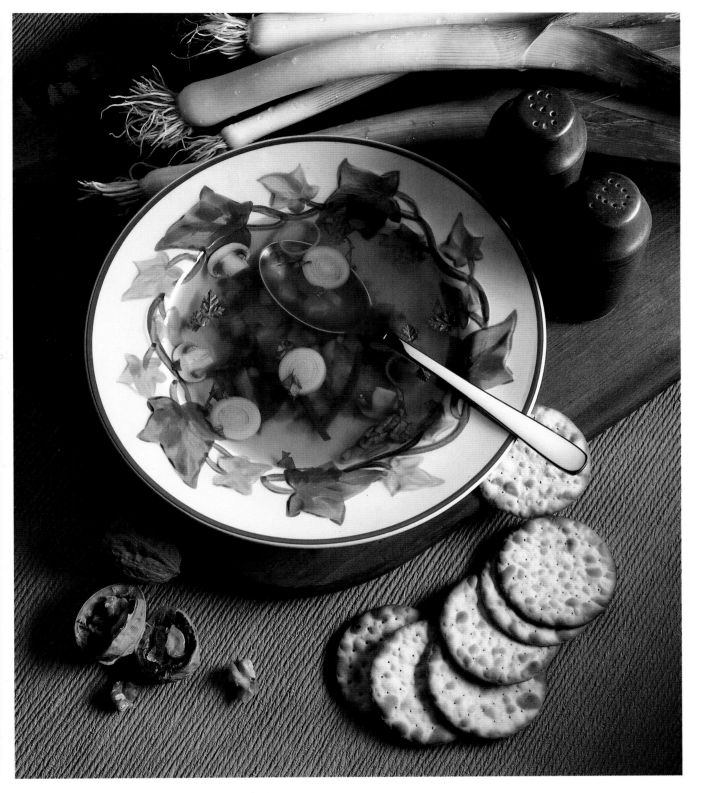

PETER DEUSSEN

PETER DEUSSEN's photography is almost entirely commercial. He works for a comprehensive list of agencies and clients in industry and fashion. He also does portraiture.

He is now embarking on a unique venture. In collaboration with Gert Dehner, the *maître* of La Crème, a Düsseldorf restaurant, he is devising a series of scenic panoramas whose hills and valleys, forests and streams, are all composed of natural foodstuffs—rather as Arcimboldo, the sixteenth-century Italian artist, painted portraits made up of food constituents. "This project," he says, "will add a new dimension to food photography."

His favourite foods are *nouvelle cuisine* and Japanese. As for cooking, he would much rather watch someone else do it than do so himself.

He is a great believer in a strong graphic approach, but he feels that this should never be so stark and stylized that it distorts the essential character of his subject. He insists that atmosphere and design must coexist in his photographs. The vividly defined wine bottle, which was shot for *International Wines*, a catalogue, is typical of his work—highly dramatic, stripped to the essentials, but still realistic.

He achieved his impact through ingenious lighting. To get the razor-sharp white outline he aimed the light directly on to the subject from the back. The effect is markedly different from the gentleness that derives from ordinary back-lighting. The angled streak of green was produced with a single narrow beam positioned to slash diagonally across the background. A flash filled in and rounded the front.

Deussen diluted the Bordeaux wine with water to get the brilliant, jewel-like claret tone. In its natural state, he says, the wine looked too dark and cloudy. He and his assistant worked on the picture for two days, and he made eight exposures.

His photograph of the opulent heap of fruit and vegetables (overleaf) was set up and shot in only six hours. It was to be projected on to a giant screen in a Düsseldorf supermarket and was designed to draw attention to the rich and abundant variety of the season's new produce. Peter Deussen put the emphasis on realism—making everything look tempting. The food was arranged by Reinhold R. Franz, a stylist. The profusion obviously derives from classic still-life paintings, as do also the dew-like droplets of moisture which were sprayed on. Nothing else was done artificially to enhance the display.

The lighting was uncomplicated. It was arranged simply, to produce highlights. Deussen made only four exposures.

Neither photograph involved any editorial consultation beyond a broad and general briefing. The inspiration, the preparation and the execution were left entirely to him.

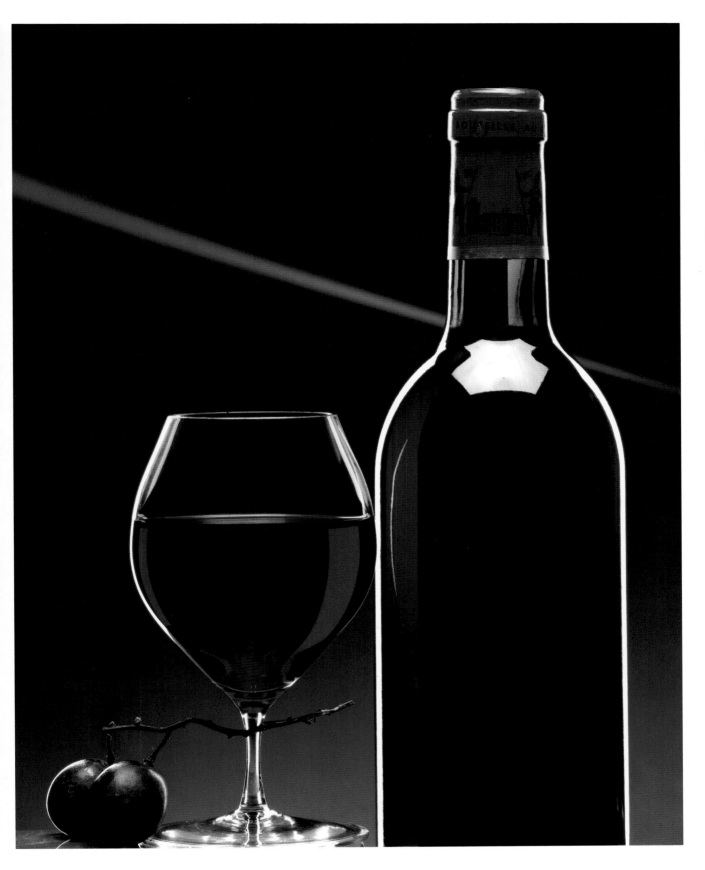

PETER DEUSSEN

PETER DEUSSEN
Studio Witzelstr. 19
4000 Düsseldorf
West Germany

Works mostly for agencies and commercial clients, including industrial and fashion as well as food.

Awards

The loyalty of his clients

TECHNICAL DETAILS

Bottle of wine
CAMERA: Plaubel
FILM: Kodak Ektachrome 64
APERTURE: f45
LIGHT SOURCE: direct lighting from the back
 to produce sharp white outline

Still life of fruit and vegetables
CAMERA: Plaubel
FILM: Kodak Ektachrome 64
APERTURE: f45

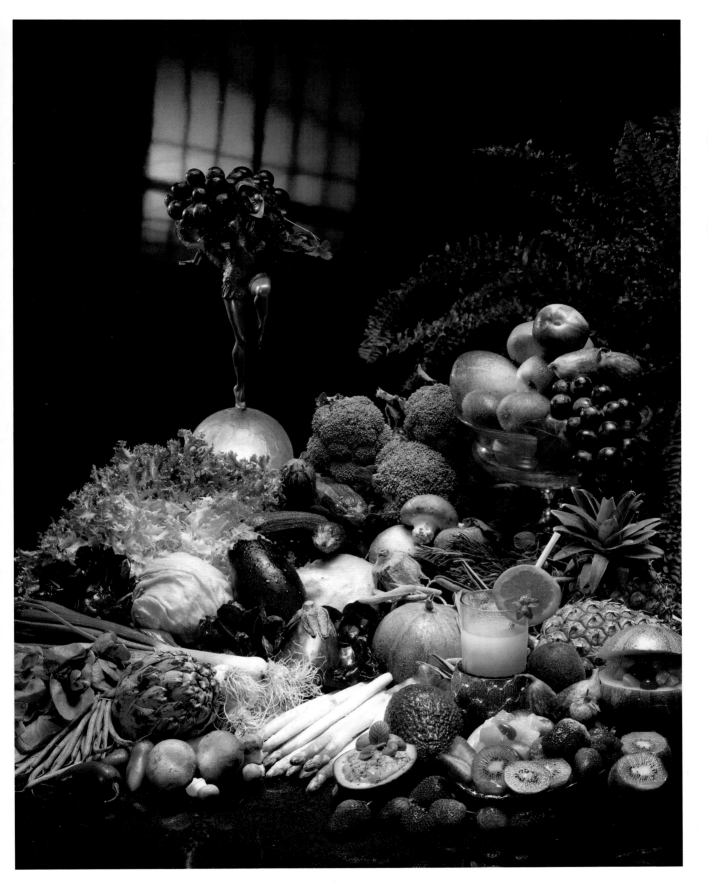

ROBERT FRESON

ROBERT FRESON follows one unwavering principle: that food is beautiful in its own right and should be "interfered with" as little as possible by the photographer. He likes to see—and to record—the ingredients in their natural state. As for the finished product, it is the cook's talent that he wants his camera to reveal. He believes that creativity is the chef's province; the photographer merely records it.

He sees himself primarily as a journalist whose function it is to capture the truth on film. Food photography is only one aspect of his career. Whether he is photographing for gastronomical magazines—food itself, restaurants, chefs—or any other subject, he seeks always to convey essence and atmosphere. His range is enormous: scientific and medical research; royalty and statesmen; fashion and auto designers; architects and architecture; engineers; great houses; national parks; famine and war. He also does advertisements and he places the same emphasis on the integrity of these photographs, whether of food or fashion, cars, planes or travel destinations. "An honest and realistic approach," he says, "sells products." He directs TV commercials—truthful ones!—as well.

He works all over the world, mainly on location, and wherever he goes he photographs food markets. They are "good windows" which reveal the tastes and habits of a place. The care and presentation of food say a lot, not only about the cuisine, but about the people who eat it.

He himself eats fairly simply. He likes American food—country meals and junk food—and the delicacies of Vietnam, Japan and Thailand. He cooks occasionally, but prefers to let his wife do it, for she produces "a marvellous and imaginative blend of European and American dishes."

Professionally, he has been stimulated by artists of many periods, from the Old Masters of Belgium, Holland and Germany through the Impressionists to such modern geniuses as Picasso, Chagall, Henry Moore and Francis Bacon. In his own field, his inspiration has come largely from pictures taken early this century, often by unknown photographers. But the greatest influence of all has been the work of the American photographer Irving Penn, whom he credits with "integrity and honesty, talent and a strength of composition that cannot be duplicated."

His double photograph of the pear tart, showing the ingredients (overleaf)—raw slices, butter, flour, vanilla, sugar, cream and eggs—and the resplendent, fragrant, finished dish perfectly demonstrates his philosophy of deferring to the talents of the chef. It has appeared in magazines—*Marie-Claire* in France, the *Sunday Times Magazine* in Britain, *Cuisine* in the United States—and in his book *The Taste of France*, which was published in the United States, Britain, France and Germany.

Robert Freson took both pictures by daylight in the kitchen of the restaurant where the tart was prepared. He used the chef's own implements and the uncluttered surfaces on which the chef cooks every day. He believes in respecting the natural environment and takes only the barest license, simplifying when essential and composing the image so that it best explains the recipe. He never distorts quantities.

He chose the subject from a group of ideas proposed by a recipe researcher and a writer from *Marie-Claire*. He assembled the props himself after watching the pastry chef put together a tart; but the chef, not he, baked this one.

Once everything had been collected, he spent three to four hours on the photograph of the ingredients and exposed probably two rolls of film—seventy-two frames at the most. His only problem was to make sure that everything stayed looking fresh while he evolved his composition. He also limited himself by working only during the best daylight hours. He devoted about the same length of time and amount of film—possibly a little less—to the finished tart. He had no need to intensify the colour values in either case and used filters only when necessary to balance the light to 5,500 Kelvin.

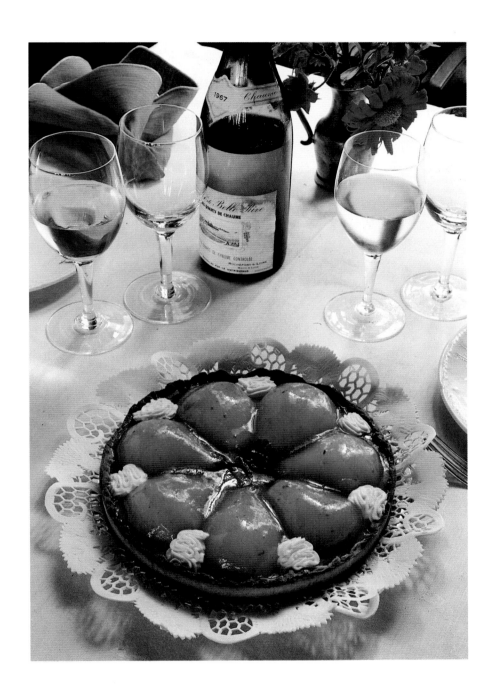

ROBERT FRESON

ROBERT FRESON
Moulin de Villiers
Archigny
86210 Bonneuil-Matours
France
and
881 7th Avenue
New York
NY 10019
United States

Major Publications

Book:
The Taste of France: Webb & Bower,
Exeter, 1983; Stewart, Tabori & Chang,
New York, 1983
Magazines including:
Cuisine
Epoca
Esquire
Essen und Trinken
Holiday
House and Garden
Ladies Home Journal
Life
Look
Marie-Claire
Match
National Geographic
Observer Magazine
Stern
Sunday Telegraph Magazine
Sunday Times Magazine
Travel and Leisure
Traveler
Venture
Vogue

Awards

Art Directors Clubs in the UK and the
United States: certificates of merit;
awards of distinctive merit; medals
Domus, Italy
Prix Littéraire des Relais Gourmands
for *Taste of France*
Glenfiddich Award for *Taste of France*
Communication Art Magazine: several
awards for excellence
Designers and Art Directors Association
of England
American Institute of Graphic Arts, New
York: certificates of excellence

TECHNICAL DETAILS

Pear tart: finished dish
CAMERA: Nikon F–1
FILM: Kodachrome 25
APERTURE: f16
SPEED: 2–4 seconds
LIGHT SOURCE: daylight, with white reflectors

Pear tart: ingredients
CAMERA: Nikon F–1
FILM: Kodachrome 25
APERTURE: f16
SPEED: 2–4 seconds
LIGHT SOURCE: daylight, with white reflectors

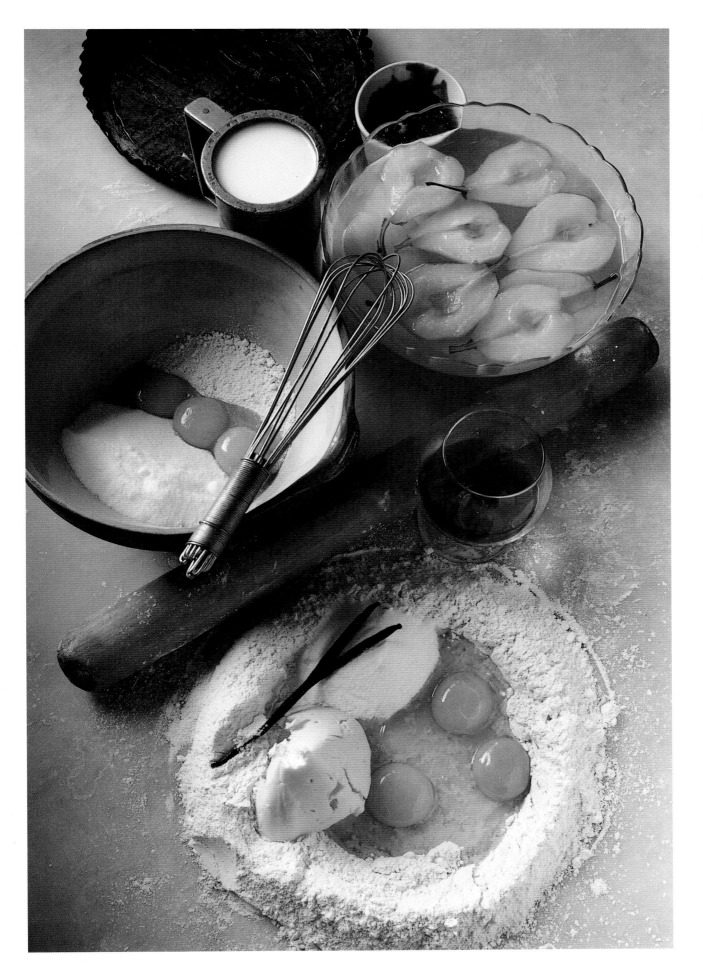

GEORGE DE GENNARO

GEORGE DE GENNARO says that the great still-life painters of the past have been the major influence on his style. "But even the best-composed still life is meaningless," he maintains, "if it has no feeling and no heart." He likes his photographs to do two things that seem almost contradictory: to bring the viewer as close as possible to the subject and, at the same time, to suggest that the scene continues far beyond what the camera shows. Intimacy and the illusion of space in a single shot—that is in essence his signature.

He mostly uses large-format film, which allows him to manage large blasts of light with small f/stops. They reproduce with elegant definition and give his editorial and advertising clients a clear idea of what the finished page will look like. He usually shoots his "how-to's" with $2^{1}/_{4} \times 2^{1}/_{4}$ and carries 35mm for the photographic notes he makes during his many foreign trips with Marjorie, his wife and business manager.

His studios are bustling places. There are two separate shooting areas, each with its own kitchen, three photographers besides himself, and a couple of food stylists and colour processors. His work is 90 per cent food photography and 10 per cent gardening, much of the latter taken in the traditional English garden that he and Marjorie have nurtured in the California sunshine.

In his pasta picture he aimed "to put the viewer's nose right over the vessel" and in the picnic, he wanted "everything within touching distance."

He believes in utter realism. "If you have to explain what a picture is," he says, "then I think you've lost it. Cold must look cold; hot, hot; and fresh truly fresh." He doesn't use substitutes and he doesn't depend on accidents. "You must make your visual effects happen.

Photographs need to be structured, ideas preconceived. You sketch your composition in advance; then you start with an empty table; and five or six hours later, you have something worth photographing."

This involves creating the right atmosphere with props that are authentic, and with lighting of the right intensity and the right colour. He almost always relies on a single light source: "That's how it is in nature. There's only one sun, shining from one direction." But if one source isn't enough in a complex composition, he bounces lights off reflectors which, again, are placed to simulate life.

He has been photographing food since the 1950s, when his innovative style ran absolutely contrary to the general trend. "In those days," he says, "the pictures looked as though they were taken from the top of a ladder, six or eight feet away. And the food was so artificially doctored up that it gave the profession a horrible name."

He chose instead to come in very close and to capture the excitement of movement. He wanted to show the animation of steam wafting, ice cream melting, meat juices oozing, to create "motion pictures that were still."

The pasta photograph, which appeared in Eastman Kodak's *Applied Photography* almost twenty-five years ago, is an early example of this technique. It took a day's shooting—ten large-format exposures—with one 3,200 watt/seconds flash, soft fills reflected from white cards and a light straw gel "to give a warm friendly feeling." Capturing the elusive steam presented the only difficulty.

The picnic scene (overleaf), taken recently for the Los Angeles *Times Magazine*, is quite different, but also typically de Gennaro. The background was photographed in France, in the Dordogne region, and by means of rear-screen projection, married to the foreground, which was staged in the studio. De Gennaro often produces such montages, using film he has already shot—possibly thousands of miles away.

For this image, a platform four feet by six feet (1.2×1.8m) was raised a couple of feet (about 0.6m) above the floor. It was covered with real meadow grass and "planted" with the same wild flowers that spattered the field in France; and a tree trunk and branches were arranged in front of the projection screen. De Gennaro and his team spent a full day roughing out the set-up, adjusting the lighting and balancing the background projection, all the while checking and rechecking with large-format Polaroids. On the second day, they fine-tuned and added all the little touches that spell drama.

Everything was authentic—the *pâté de foie gras*, the duck *confit*, the *tarte aux fraises des bois*, the baskets, the glasses and the classic French knife, all came from the Dordogne. Duplicate foods were used during the hours of "rehearsal" and the actual dishes, the "heroes," as they are known—the *confit* brushed with its own juices, the lettuce and tomatoes sprayed with water—were brought in at last for the shooting. De Gennaro took fifteen large-format exposures.

A wide 165mm lens and a very low angle bring the viewer right into the picture. The effect of dappled sunshine seamlessly blending from the set into the projection comes from diffusing 5,000 watts of tungsten light through spun glass and bouncing it off assorted white cards and mirrors as fills.

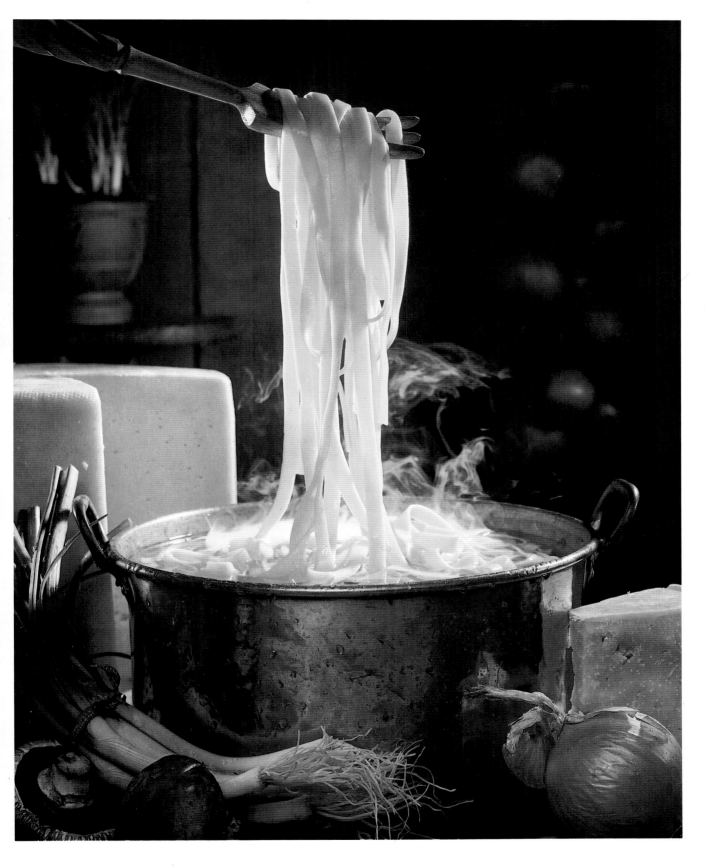

GEORGE DE GENNARO

GEORGE DE GENNARO
1957 Mandeville Canyon Road
Los Angeles
California 90049
United States

Major Publications

Editorial and advertising work has
appeared in nearly all the major
American food and home furnishing
magazines, in award-winning cook
books, in packaging and in point-of-sale
displays.

Awards

Numerous editorial and advertising
awards

TECHNICAL DETAILS

Pasta
CAMERA: Deardorff
FILM: Kodak Ektachrome 64
APERTURE: f32
SPEED: 1/50 second
LIGHT SOURCE: studio flash 3,200 watt/
 seconds

Picnic
CAMERA: Deardorff
FILM: Kodak Ektachrome 64
APERTURE: f45
SPEED: foreground 12 seconds, background
 60 seconds
LIGHT SOURCE: 5,000 watts of tungsten light
 bounced through spun glass diffuser

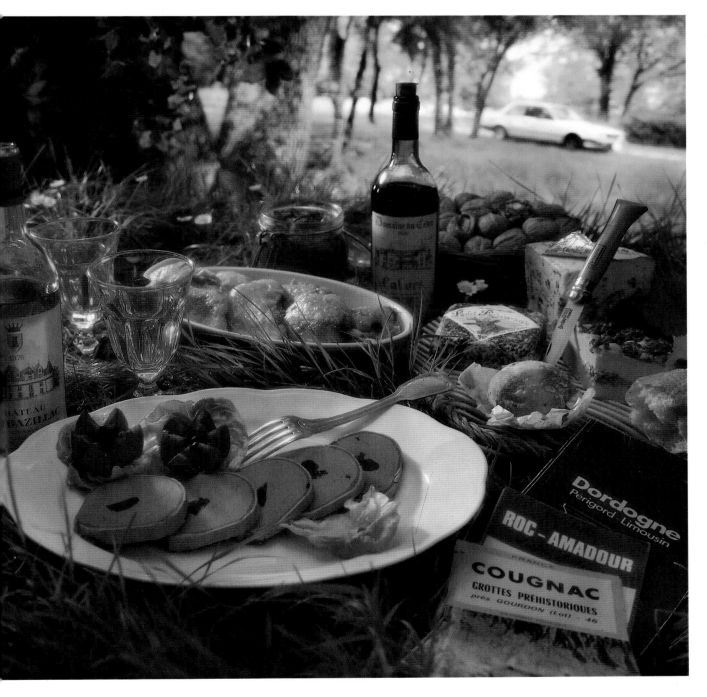

George de Gennaro

JOOP GREYPINK

JOOP GREYPINK concedes that he may subconsciously be influenced by modern painters, but says that the major inspiration for his technique comes "from my own head."

He is something of a gastronome and enjoys cooking, especially French and Indonesian cuisine. The latter, a speciality of Holland, is a natural choice since he is Dutch; but he lives in Germany and his assignments are mostly in Germany, Italy and Holland.

He shoots not only food but "everything that doesn't move," including live nude models, who qualify because they "keep very still." He recently won an award with a photograph he took of a nude model to accompany a poem in a West German literary magazine.

He vehemently dislikes the triteness of most commercial food photography. This is ironic, since the majority of his work is for advertising, where, he says, "the word 'cliché' is written in huge capital letters." Whenever he gets a free hand, he escapes into photography as far away in spirit as possible from the glorification of the pre-packaged and the boredom of table accessories—the napkins, the plates, the cutlery.

His own key word is "simplify." He avoids the "clutter and confusion of unnecessary props" and brings his camera in as close as possible to his subject. He adds to this a strong stamp of originality, as his photographs of the truffle and the trout both show.

"Very expensive stuff!" he says of the truffle and champagne picture (overleaf) giving this as his reason for choosing it. But what is far more important is that it perfectly exemplifies his *credo*. It is one of a series of four seasonal posters for a famous restaurant in Düsseldorf, West Germany, each of which showed only a beverage on the left and a single food item—a spear of asparagus, an oyster, a herring—on the right.

Shooting it was practically effortless. He allowed a day in the studio and produced ten shots on large-format film in about an hour. Working with one assistant, he arranged a simple set-up lighted at the front by a flash strip about three feet (1 metre) away from the glass and the truffle and at the back by a Plexiglas screen. He never uses filters of any kind. His pictures show exactly what his eyes see.

What he sees is always meticulously preordained. He plans every nuance in advance. "But always in my head," he says, "never on paper, because I cannot draw or sketch."

The only difficulty with this photograph was the tantalizing aroma of the black Périgord truffle. It is his favourite food and he could hardly wait to get the shooting over and the eating started.

The shot of the trout ostensibly being hooked while swimming among the ingredients of a fish bouillon was quite complex. Joop Greypink created it for a personal promotion poster with the catch-line, "Fishing for a still photographer?" He ordered twenty live trout from the fishmonger and chose the most beautiful. Sabine Mirus, his food stylist and home economist, prepared the fish by boiling the part of the body that was to be submerged and made the wine jelly in which it and all the other ingredients appear to be floating. The photographer and his two assistants took two days and thirty exposures to capture the scene as he had envisaged it.

The trout was fixed in the aquarium with weights and the fluid jelly poured in afterwards. Everything else—the dill, the bay leaf, the peppercorns, the carrots, the leek—had to be arranged in their respective positions at different times as the jelly stiffened, according to their differing specific gravities, the heaviest first and the lightest last. The process took some four to five hours.

The trout had been boiled to give it a bluish hue, which was unfortunately counteracted by the yellowish tinge of the wine jelly. Greypink corrected this in the printing.

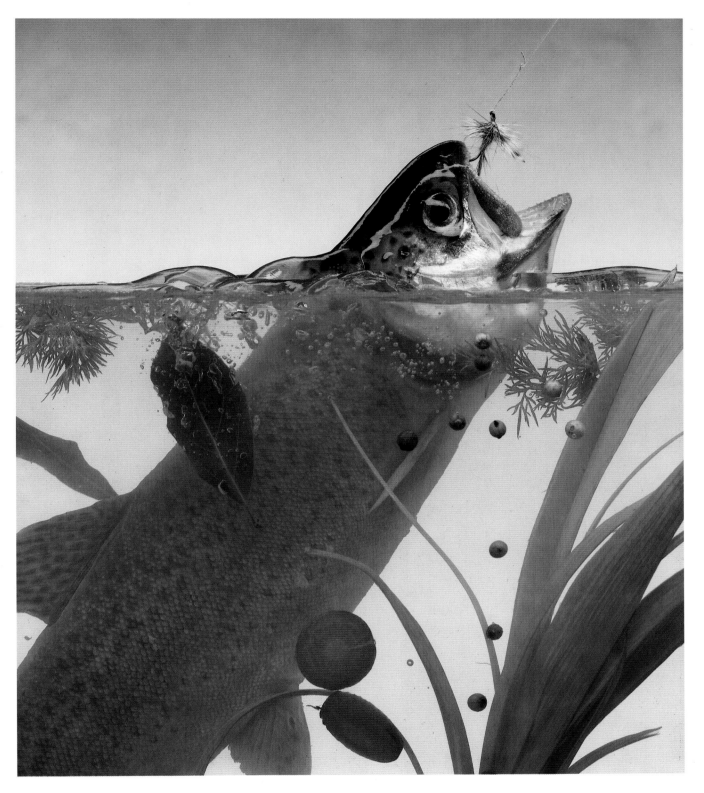

JOOP GREYPINK

JOOP GREYPINK
Gauss-Str. 20
4000 Düsseldorf 1
West Germany

Major Publications

Book:
Sprossen und Kelme, Wilhelm Heyne
 Verlag, Munich, 1987
Magazines:
Color-Foto
Pubblicità Domani
Select
Stern

Awards

Art Directors Club of Germany Award
 in 1979/80 and 1986

TECHNICAL DETAILS

Trout in wine jelly
CAMERA: Sinar
FILM: Kodak Ektachrome 64
APERTURE: *f*64

Champagne and truffle
CAMERA: Sinar
FILM: Kodak Ektachrome 64

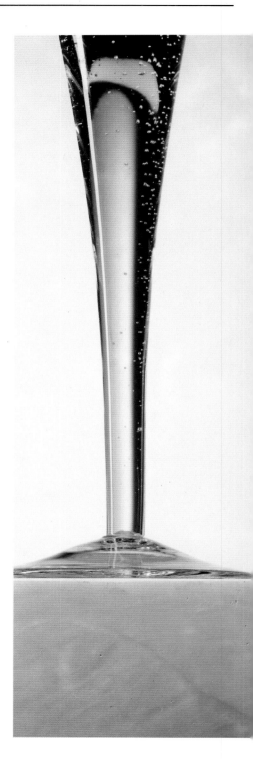

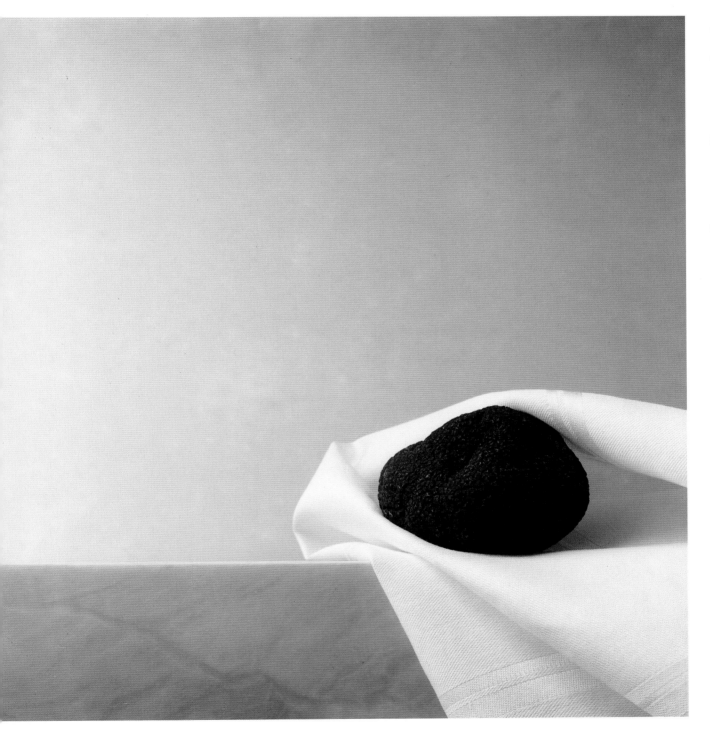

Joop Greypink

CHRISTINE HANSCOMB

CHRISTINE HANSCOMB became a photographer after spending ten years as an art director for Condé Nast publications. "I learned from the other side," she says. "I worked in the *Vogue* studios with photographers on every kind of project—fashion, still life, beauty, food, décor." As a student she had taken a degree course in graphics and ever since then she had always carried a camera. Exposed at *Vogue* to professional photographers day after day, she gradually realized that she would rather join them than direct them. She did just that in 1979.

She has a varied career, photographing still lifes, interiors and people, young and old. But food is her speciality. One of her first assignments was for a food book which led to another—and another—and many more.

She uses the word "minimalism" to describe her approach to her work. By this she means that she cuts away everything extraneous to produce one single unambiguous statement. Both the photographs that she has chosen demonstrate her devotion to the high drama of simplicity. Nothing that is unnecessary is included.

"But a picture," she says, "must have excitement as well. This can come from the lighting—the contrasts you can get with light and dark, the moods you can create with shadow. Or it can come from the subject matter itself; if it is food it must look wonderful. Or it can come from the situation—from something unexpected, for instance, something subtle that you suddenly see when you're shooting on location. In the studio, of course, it comes to a large extent from the composition."

In her photograph of prawns and hundred-year-old eggs, she produced the excitement in two ways: with her graphic composition and with her use of lighting from below to emphasize its geometric simplicity. It appeared in *Departures*, the American Express magazine, to illustrate an article on Chinese cooking. She and the magazine's art director concurred on the general approach.

"I wanted a two-dimensional look in this case," she says. "I concentrated on flat shapes—circles within a rectangle—and I shot from above." She positioned the ingredients so that they were integrated into the overall graphic form. The outlines were sharply delineated by being placed upon glass and deftly lighted. She used two Bowens Quads, the first placed to one side and the second beneath the glass.

She always visualizes in advance exactly what the finished photograph might look like. "But I do it in my head," she says. "Never with a sketch on paper."

She spent about a day on this picture in her studio, aided by an assistant and Antonia Gaunt, a food stylist, who assembled the props. When it had been set up, she made ten exposures rapidly so that none of the freshness of the food was lost.

She took her second photograph, the mayonnaise shot (overleaf), for the sheer joy of doing it. She had finished a long day's session for the *Sunday Times*, working on a rather elaborate set-up for mayonnaise. It included salads, bowls and an assortment of props collected by Antonia Gaunt. The mayonnaise itself had been prepared by Linda Maclean, a home economist.

"When that job was finished," Christine Hanscomb says, "I started to minimalize." She reduced the array of objects to what she saw as the essentials and arranged them on a marble surface against a painted background. The pattern of shapes and tones is reminiscent of the early Dutch masters, by whose work she has been greatly influenced.

Her lighting here was from the side with a Bowens Quads 8,000 head, plus tungsten. Again she made ten exposures. There was only one slight problem—to keep the mayonnaise from "skinning."

Her food tastes are like her approach to photography: simple but stylish. She likes to eat, as well as to shoot, fresh and raw foods, pasta, good cheese, brown bread. In her cooking, the pattern persists: "Simple pasta or the occasional Indian or Italian dish, beautifully arranged for lots of friends."

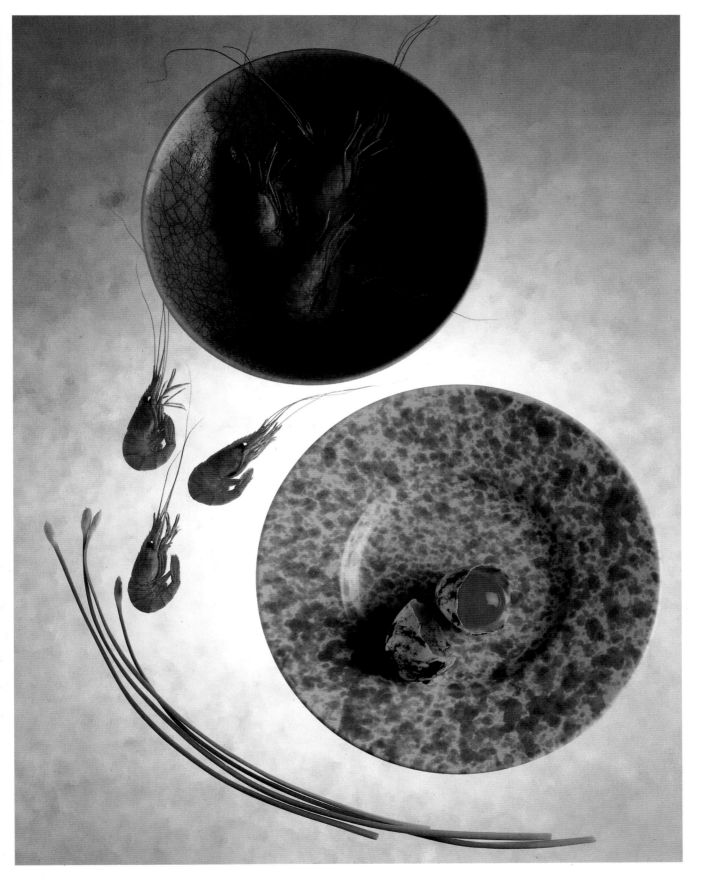

CHRISTINE HANSCOMB

CHRISTINE HANSCOMB
11 Perseverance Works
38 Kingsland Road
London E2 8DD
United Kingdom

Major Publications

Books include:

Chinese Delights (Lisa Kinsman), Jill
 Norman, London, 1982; Atheneum,
 New York, 1983

The Cook Book (Terence Conran),
 Mitchell Beazley, London, 1980;
 Crown, New York, 1980

Country Kitchens (Jocasta Innes),
 Weidenfeld and Nicolson, London,
 1979; Garden Way Storey Publishing,
 Pownal, 1982

Invitation to Italian Cooking (Antonio
 Carluccio), Pavilion Books, London,
 1986; *A Taste of Italy*, Little Brown,
 Boston, 1986

A Taste of India (Madhur Jaffrey),
 Pavilion Books, London, 1985;
 Atheneum, New York, 1986

Visual Delights (Natalie Hambro),
 Conran Octopus, London, 1985; Little
 Brown, Boston, 1986

Many major magazines including:
Good Housekeeping
Observer Magazine
Sunday Times Magazine
Vogue

Has worked for most of the major
advertising agencies, including Saatchi
& Saatchi (Campbells Soups), WCRF
(Sharwood) and Bartle Boggle Heggarty.

TECHNICAL DETAILS

Prawns
CAMERA: Sinar
FILM: Kodak Ektachrome 6117
APERTURE: f45
SPEED: 20 seconds
LIGHT SOURCE: two Bowens Quads

Mayonnaise
CAMERA: Sinar
FILM: Kodak Ektachrome 6117
APERTURE: f45
SPEED: 30 seconds
LIGHT SOURCE: side light, Bowens Quads
 8,000 head, tungsten

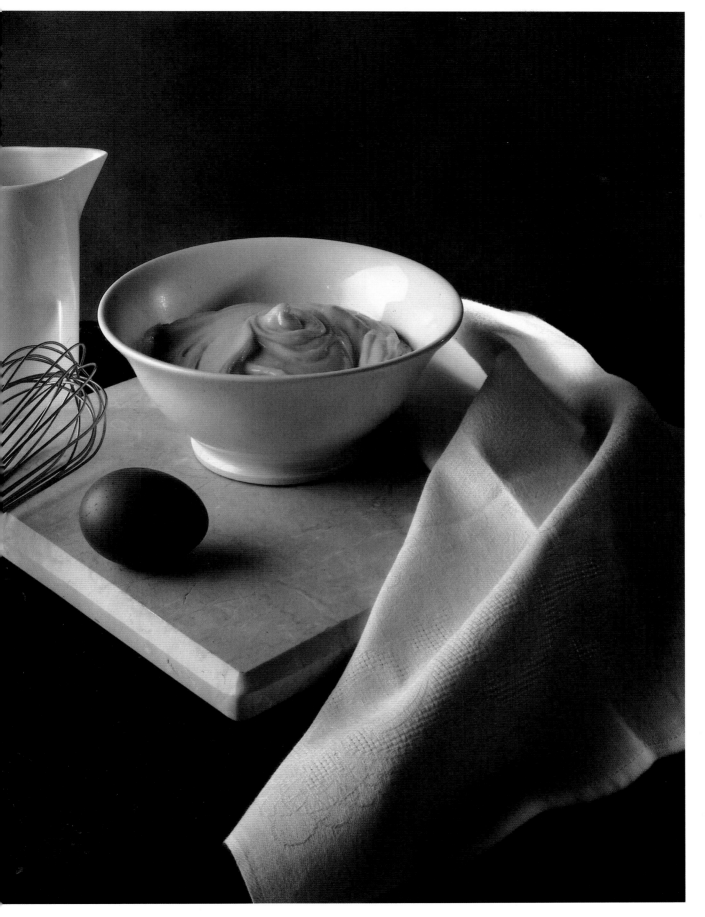

PIERRE HUSSENOT

PIERRE HUSSENOT's career combines editorial and commercial work and includes a great deal besides food photography. He has, however, come to be identified largely with cooking. *Time Magazine* called *Roger Verge's Entertaining in the French Style*, which he illustrated, "the most beautiful food book of the year." The reviewer commented: "The food photographs are as tantalizing as the table settings and the sun-dappled impressionistic outdoor scenes in the south of France."

Hussenot likes to cook, "everything except pastry," but he never does so for his own photography.

His inspiration, as his two chosen photos show, obviously owes much to the seventeenth century, but equally as much, he says, to the twentieth century's Irving Penn. "How could one not credit him?" he asks. "He is the father of us all!"

Hussenot's glowing picture of *jambon en croûte* for the French magazine *Figaro Madame*, deliberately echoed the manner of the great Flemish still-life artists, making telling use of light and subtle tones.

There was no editorial direction. He was given the assignment and left to get on with it, assisted by a stylist and by the restaurant chef, who baked the golden-crusted ham. He composed the picture in his studio, setting it up on an antique linen cloth against a softly mottled background which he painted himself.

The vegetables were slightly under-cooked to keep them from losing their colour, but they, like the ham, were not prettified or falsified for the camera. Hussenot likes everything to be completely natural. This includes the lighting, which he employs to emphasize contours and establish dimensions. He almost never uses direct light. In this case, he combined available daylight with flash.

He worked for a day on the photograph and, after several test shots, made only one exposure.

His second picture (overleaf), also in the mould of classic still life, illustrates a Mexican recipe for turkey cooked with chocolate. It was part of a reporting assignment for *Marie France* magazine, taken on location in Mexico. He and the stylist together sought out the ideal site, an atmospheric old hacienda, and found the early Mayan bowl and the time-honed wooden table nearby. They shopped in the local markets for the turkey, fresh produce and spices.

As always, Pierre Hussenot was preoccupied with the lighting, and chose to arrange his composition against a faded ochre wall at the end of a long gallery-like courtyard, and shot very late in the afternoon when the natural light was mellow and evocative. He used no subsidiary lights.

He worked on the picture for about half a day. Again, after a few tests, he made only one exposure.

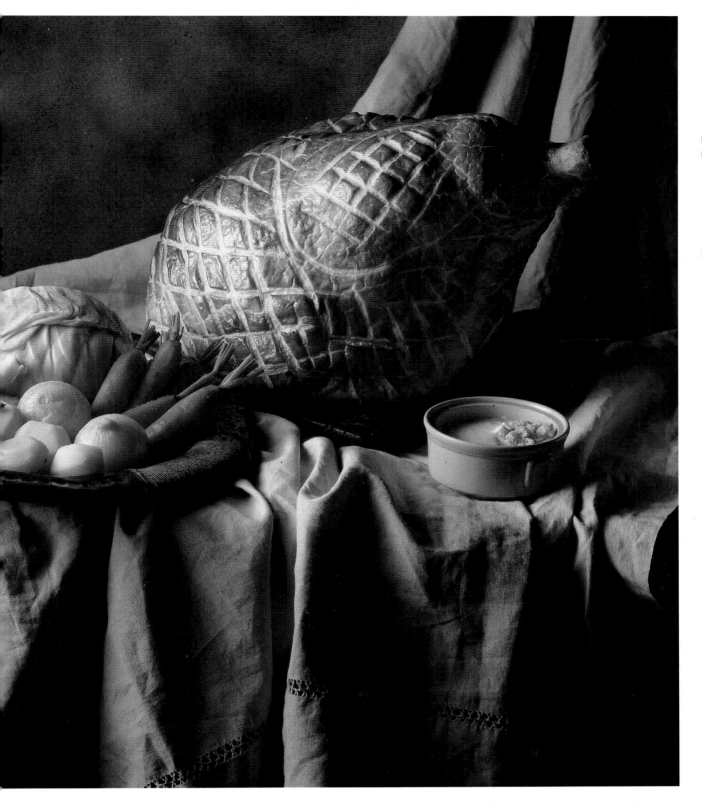

PIERRE HUSSENOT

PIERRE HUSSENOT
19 passage Larousse
92240 Malakoff
Paris
France

Major Publications

Books:

Roger Verge's *Entertaining in the French Style* (Roger Verge): Stewart, Tabori & Chang, New York, 1986; Webb & Bower/Michael Joseph, Exeter/London, 1986

Many French and Italian magazines including:

Figaro Madame

Marie-Claire

Marie France

Work for brochures, pamphlets and other material for commercial organizations.

Awards

Prix Curnonski, 1986: for the best cook book, Roger Verge's *Entertaining in the French Style*

TECHNICAL DETAILS

Jambon en croûte
CAMERA: Sinar
FILM: Kodak Ektachrome 64
APERTURE: *f*32
SPEED: 2 seconds
LIGHT SOURCE: daylight and flash

Turkey with chocolate
CAMERA: Sinar
FILM: Kodak Ektachrome 64
APERTURE: *f*32
SPEED: 1 second

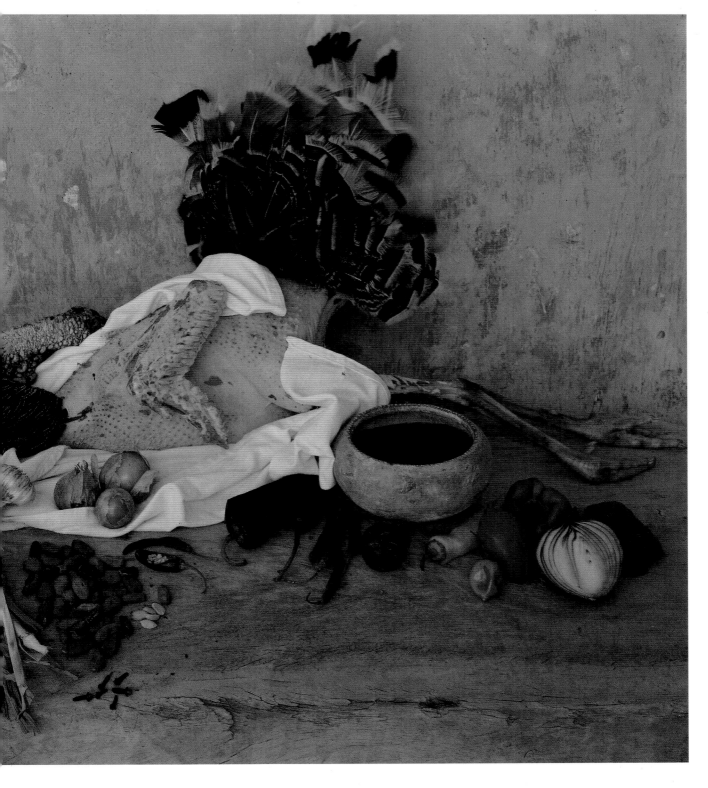

PETER JOHANSKY

PETER JOHANSKY calls himself a "fortunate fellow" because he is given *carte blanche* by almost all his art directors. This freedom, he feels, comes only with editorial photography. "In advertising," he says, "I must conform to the client's wishes. Editorial people don't pay as much, but they make up for it by letting me have a lot of say in everything I do."

Ninety per cent of his work is with food—"such a joyous subject"— and the rest with beverages, products in general, and people.

He has been strongly influenced by university design courses and by modern artists, chiefly Andy Warhol and Jasper Johns. He advanced his own technique—this "extremely fortunate fellow"—by studying with two of photography's contemporary giants, Ansel Adams and Philippe Halsman.

He enjoys cooking the Czech dishes he was raised on—stuffed cabbage, *pieroges*, *kielbase*, *bigos*—but never to photograph. "Food is a specialized subject," he says. "I rely on the specialized support of experts."

He is almost never asked to work within the confines of a predetermined layout. His shoots tend to be creative sessions when he, his assistant, the food stylist and usually, though not always, the art director, work together. This was the case with the two photographs shown here. The lobster chowder and the chicken breasts (overleaf) were both covers for the American magazine *Food & Wine*, and both evolved through his self-invented, freewheeling system in which the telephone seems to be as integral as the camera.

First, he phones the art director and discusses the general look and the props. Next, he has lengthy chats with the props stylist indicating what he has in mind—the background, the kinds of containers, their shapes, colours and sizes. Sometimes he asks for glassware or china by particular designers. He also specifies little extras, like the dice in the lobster picture, which were tossed in as a visual pun on the headline copy: "Twenty-Five Hot New Chefs and Their Winning Dishes."

But nothing is finally decided until the team gathers in his studio. "The sessions can be exciting," he says. "Sorting through the props for the perfect plate, spontaneously designing in the camera, shooting large-format Polaroids, quickly changing the background, rearranging the composition." He points out, however, that while this free abandon is stimulating, it also brings great responsibility.

Elizabeth Woodson was the art director for both assignments. Rick Ellis was the food stylist for the lobster chowder, an image that Johansky thinks of as his own signature. He is fond of the "design-y" graphic quality and of the propping. The black half of the background is a rubber doormat; the grid half is a printed bedsheet and the decorative whorls and geometric shapes are holders for table napkins.

Johansky took this photograph a couple of years ago, and although it pleases him, he doubts that he would do it in the same way today. He now favours more subdued colours, and even uses monochromatic schemes. He feels that this trend is growing, in design in general and in food photography in particular. "Things are also becoming more traditional," he says. "A touch of romanticism is creeping back."

The chicken breasts photograph is also graphic but more realistic. It was a New Year's cover, and he established a festive air with the generously filled platter (more in the mood of the 1950s than the 1980s), the confetti, the serpentine streamers and the frilly New Orleans party mask. Susie Harrington was the food stylist.

Peter Johansky shot both these photographs looking straight down, an angle he is fond of for food. In general, he lights to emphasize texture, placing a side light at a low angle, so that it skims the plate and picks up characteristic crevasses. And he exposes for maximum colour saturation, which means underexposing a little—"Too much, and you flop!" For both shots, he used only one large flash bank light (he now tends to use two) and lit the chicken from under a sheet of white Plexiglas.

Each session lasted about three hours. He took seven shots of the lobster on large-format film and five of the chicken, both bracketed. Neither fish nor fowl was quite tender enough to eat; they had been undercooked to enhance their colour, which is about as far from culinary truth as Johansky ever strays.

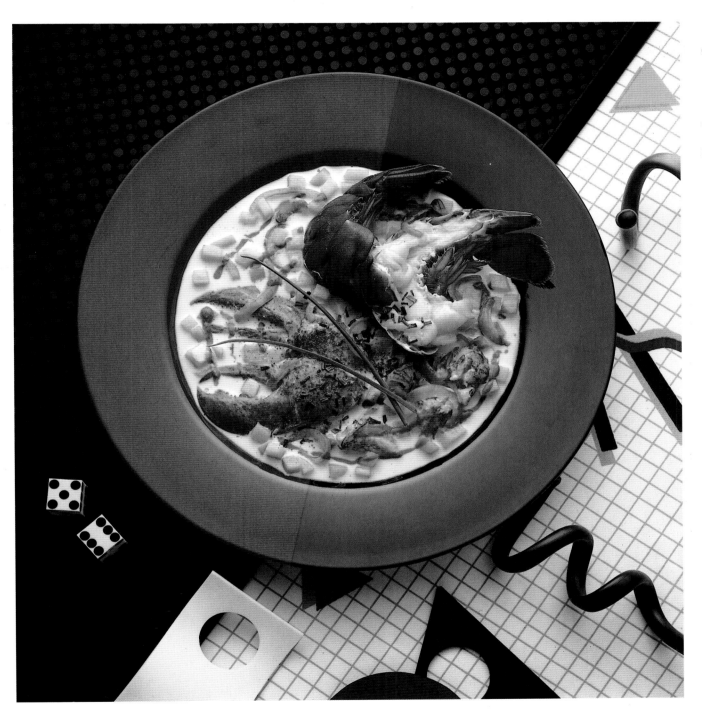

PETER JOHANSKY

PETER JOHANSKY
27 West 20th Street
New York
NY 10011
United States

Major Publications

Books:
American Bistro (Irene Chalmers),
　　Contemporary Books, Chicago, 1986
The Best of Food & Wine (ed. Food &
　　Wine), Doubleday, New York, 1984

Magazines:
Esquire
Food & Wine
Good Food
Home Entertainment
Il Piacere
New Body
Parents
Weight Watchers

Major advertising clients include
Borden, Lever Brothers, Beecham
Products, Proctor Silex, Panasonic,
Warteck Beer and Procter & Gamble.

Awards

Creativity Eighty-One: Certificate of
　　Distinction for ABC Network Radio
　　advertisement

TECHNICAL DETAILS

Lobster chowder
CAMERA: Toyo View Model G
FILM: Kodak Ektachrome 100
APERTURE: f45–64
LIGHT SOURCE: flash

**Chicken breasts with rosemary and
　　garlic**
CAMERA: Toyo View Model G
FILM: Kodak Ektachrome 100
APERTURE: f45–64
LIGHT SOURCE: flash

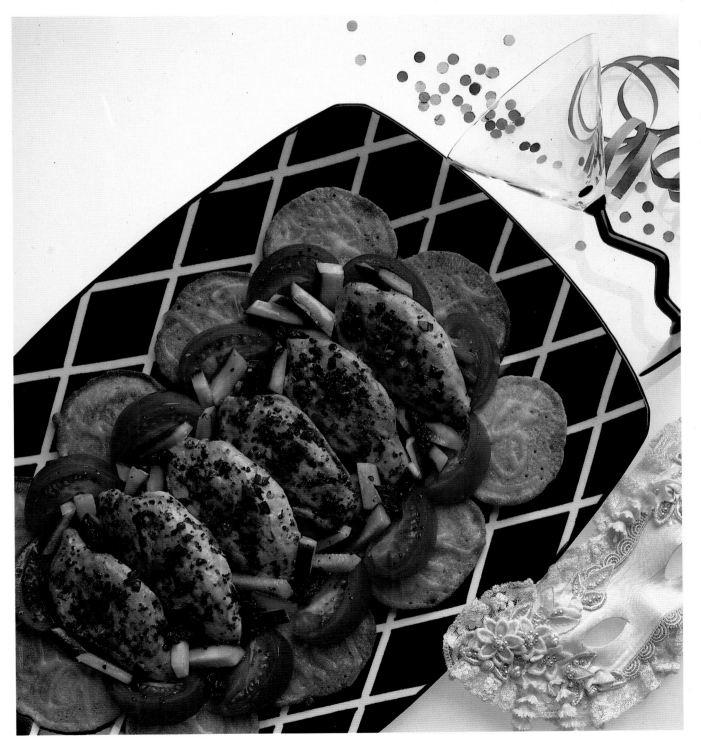

Peter Johansky

JHON KEVERN

JHON KEVERN's work is almost entirely for advertising and nearly always, in one way or another, involved with food. He does a lot of table-top photography and a great deal of photographic reportage largely to please himself. He is never without a camera. "I like to capture the accident of the moment," he says, "and then I try to create it again in the studio." This often leads to solitary contemplation. "I like to be left alone—lost in a picture—to work out what it is that I like about the idea."

He has been strongly influenced by paintings—"almost every genre"—and by the photographs of Irving Penn. Cooking is almost as much a part of his life as photography. He dazzles his guests with unusual foods from all over the world and with elaborate recipes that he has eaten in fine hotels and restaurants. Often, delighted with a dish he has prepared, he whips out his camera and takes its picture.

He enjoys injecting into his photographs a mood that goes beyond the factual recording of a subject. He chose the shots of the bicycle and the ice cream because "they both suggest an imaginary time and place" and invite the viewer to add a further imaginative dimension of his own.

To him the photograph of the bicycle expresses the essence of simple French food and at the same time implies something more. "An assignation, perhaps?" he asks. "Or just a farmer stopping for lunch?" The second, the ice cream in the brandy-snap basket (overleaf) is, he says, Italian in feeling and "reminiscent of past grandeur." It might be a lonely circumstance, he feels, except that the light streaming through the door hints at another presence.

He devised both as promotional posters to send to his clients. They are also sold in galleries in Britain and on the Continent.

For the bicycle shot, he began with the colour blue, which conjures up memories of France and the Mediterranean. Then he added a few simple French components—the wine, the bread, the sausage, the bicycle itself—to create an evocative expression of unsophisticated pleasure.

For the brandy-snap basket, he devised a miniaturized room setting, the smallness of which accentuates the food and provides perspective without the distracting nuisance of distortion. "Painters can play about with perspective," he says, and he can see no reason why photographers should not do the same.

The shot is stylized to suggest decaying elegance. It was one of a series of three illustrating three courses of a meal, each in a different setting. The unifying motif is the light flowing through a partially open door.

Kevern's wife, Valerie, is a food stylist and they collaborated closely to achieve these two shots.

The wall for the bicycle picture was built and painted in his studio, and the set was lit and propped over two days. It took a third day to make ten or twelve exposures, lit by a 2,000-watt spot and shot through a coarse mesh diffuser.

The second was more complex and took five days in all. Careful working drawings were made for each of the three room settings in the series, and a three-dimensional model was then erected in front of the camera, so that the perspectives and positioning could be adjusted before the actual set was built by a model-maker.

Jhon Kevern and Elaine Bastable, a food stylist, spent a day in rehearsal, working out positions, testing film and lights and, most important, making certain that he would have two to three clear minutes of shooting time—long enough for fifteen to twenty exposures—before the ice cream began to melt. The lighting was by electronic flash, the main light having been taken to pieces and reconstructed in the studio to make it extremely soft. It was reflected on to the ice cream through a plastic diffuser, to soften it even further.

Jhon Kevern resists using phoney food substitutes. He will if he has no choice, but, on ethical grounds, he prefers the real thing. This may involve using non-melting stand-ins for rehearsals—as was the case in this ice cream shot—and rushing back and forth between freezer and camera when shooting actually begins.

Jhon Kevern

JHON KEVERN

JHON KEVERN
16/17 Novello Street
London SW6 4JB
United Kingdom

Works almost entirely for advertising
agencies, except for his personal art
posters.

TECHNICAL DETAILS

Bicycle
CAMERA: Sinar
FILM: Kodak Ektachrome 50
APERTURE: *f*8
SPEED: $^1/_8$ second
LIGHT SOURCE: 2,000-watt tungsten spot
 through coarse mesh diffuser

Ice cream in brandy-snap basket
CAMERA: Sinar
FILM: Kodak Ektachrome 64
APERTURE: *f*16
LIGHT SOURCE: Alpha flash, shot through
 plastic diffuser

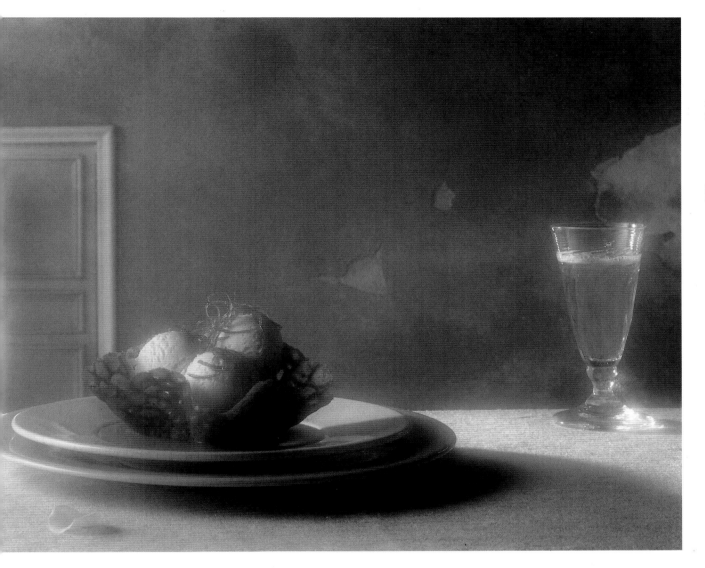

Jhon Kevern

KATHRYN KLEINMAN

KATHRYN KLEINMAN credits a number of artists in related fields for inspiring her approach to photography—the sculptor Isamo Noguchi; the photographers Irving Penn, Man Ray, Imogen Cunningham and Paul Outerbridge; and the painters Pablo Picasso, Georgia O'Keefe, Jasper Johns and Robert Rauschenberg.

She likes to eat out and says: "In California, the American cuisine is now very exciting, and we have some of the country's greatest chefs." Her first choices are Japanese, Thai and the "new" American foods. Her own cooking tends to be simple, because it must conform to the tastes of her two-year-old son.

She does still-life illustrations of many subjects, but food and flowers appeal to her most, because "I enjoy the beauty of nature." She sometimes shoots her own food professionally, but only in its natural state. For prepared dishes she relies heavily on a stylist. "Most beautiful food in a photograph is created by a team doing what they do best—often an art director, a food stylist with an assistant, a representative of the client and the photographer's assistant. It isn't fair for the public to think that the photographer does it all!"

She is drawn to simple beauty in her work and in her life. She disdains photographic tricks and strives to make her pictures realistically beautiful. The two shown here fully satisfy this aim, with the light, as she describes it, "bathing the food elements in its glow."

Both were shot for *Salad*, an award-winning book on which she collaborated with Amy Nathan, the food stylist who wrote the text and prepared the dishes. The salad appears on the book jacket; the bottles (overleaf) are for the opener of the section on oils and vinegars. Together, Kathryn Kleinman and Amy Nathan produced all of the many dozen shots in the book. They chose the props—only simple clear glass and white linen throughout—"to enhance rather than distract from the food." And they constantly "checked each other's feelings" to make certain they agreed on the point every photograph was to make and on what it should contain.

Jacqueline Jones, a designer, helped them to evolve the overall presentation of the "vision" they wanted to project. The style is consistent throughout. All the photographs were realized by surrounding the subjects in white light. "The clear glass plates were essential so that the light would pour through." Back-lighting was equally essential "to capture the delicacy, lightness and freshness" of the lettuces and the other salad greens. This imparted a translucent look which emphasizes their frail, fine texture.

Kathryn Kleinman kept the light constant for the entire project, but varied the perspective, shooting at a forty-five-degree angle for the ingredients, and at ninety degrees to look straight down at the completed dishes on their plates. Although seven months pregnant, she took turns with Amy Nathan on the ladder to evaluate the effect of each set-up on the Plexiglas sheet below. She then made test Polaroids. "The only way," she says, "that a food photographer can prevent mistakes."

Every day for many weeks, fresh greens were delivered to her studio from a San Francisco market garden. Even so, decisions had to be quick and accurate and photography almost instantaneous to keep everything looking as though it had just been picked. 'When you're shooting something as fragile as lettuce," Kathryn Kleinman says, "too much heat can destroy the crispness." She used only studio flash—a powerful back-light and an overhead fill—and shot at $1/125$ second. The ratio was about two to one, bottom to top, so that the light would flow up from beneath the Plexiglas plate.

She tested and colour-balanced the film beforehand, to make sure that when she pressed the shutter the light would be right and the exposure perfect. "This," she says, "is imperative with white light, which can be tricky. My main concern was to keep it neutral." Each session took about four hours and produced four sheets of film.

Lighting to her is the most important element in creating the proper ambience. But the camera viewpoint matters almost as much. "You could never photograph some foods looking straight down on them, as I have done with these salads. It is vital to have the strongest possible viewpoint in every case."

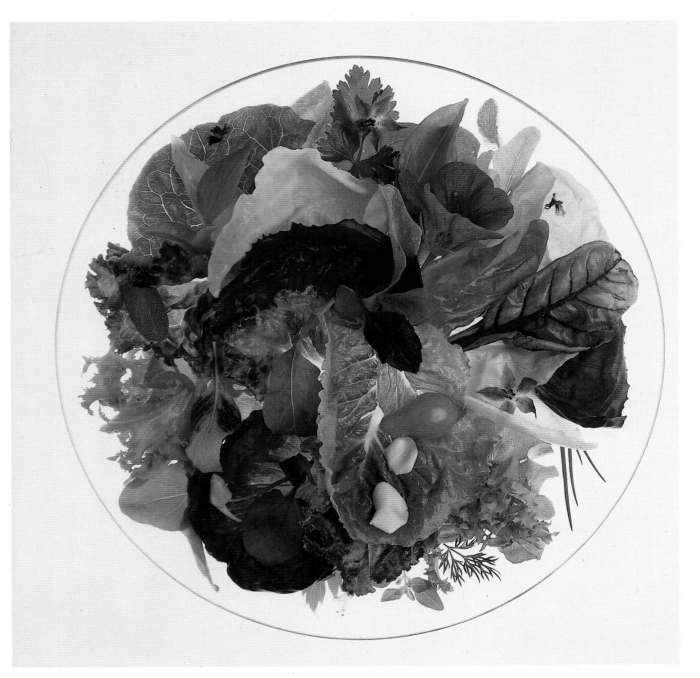

Kathryn Kleinman

KATHRYN KLEINMAN

KATHRYN KLEINMAN
542 Natoma Street
San Francisco
California 94103
United States

Major Publications

Books:
Arranging Cut Flowers (Al Horton),
 Ortho Books, San Francisco, 1985
Fruit, Chronicle Books, San Francisco
On Flowers, Chronicle Books, San
 Francisco
Openers, Chronicle Books, San
 Francisco
Salad (with Amy Nathan), Bell &
 Hyman, London, 1986; Chronicle
 Books, San Francisco, 1985
Sushi (with Mia Detrick), Chronicle
 Books, San Francisco, 1981

Awards

Communication Arts Magazine Annual
 Award of Excellence: *Sushi* and
 Salad
American Institute of Graphic Artists
 Certificate of Excellence: *Sushi* and
 Salad
New York Art Directors Club: *Salad*
California American Institute of Graphic
 Artists Design Award: *Salad*
Bookbuilders West Certificate of Merit:
 Salad
STA (a professional communication
 design organization) 100 Award of
 Excellence: *Salad*

TECHNICAL DETAILS

Salad
CAMERA: Sinar
FILM: Kodak Ektachrome 64
APERTURE: *f*32–45
SPEED: $^1/_{125}$ second
LIGHT SOURCE: studio flash

Bottles
CAMERA: Sinar
FILM: Kodak Ektachrome 64
APERTURE: *f*32–45
SPEED: $^1/_{125}$ second
LIGHT SOURCE: studio flash

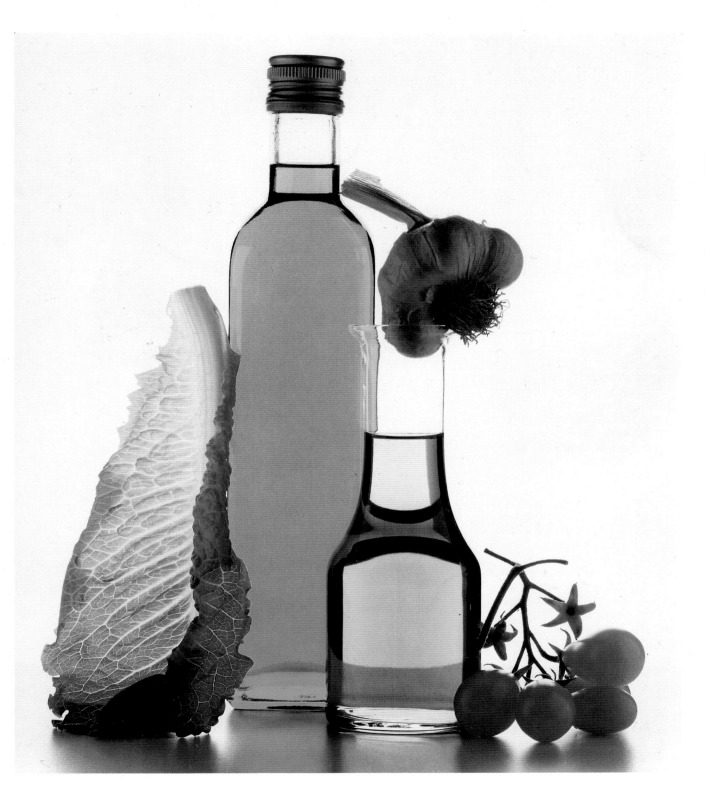

Kathryn Kleinman

ALLEN LIEBERMAN

ALLEN LIEBERMAN has difficulty defining his style, except to say that he enjoys making realistic photographs that are full of movement and excitement. Once he gets an idea and starts to put it together, he lets it go on willy nilly, whatever may happen, whatever direction it may take, whatever shape and proportion it may assume.

He shoots a variety of still lifes, including alcoholic drinks as well as food, for commercial and editorial clients. He is particularly fond of Japanese and Italian food, and can turn out a first-rate Italian meal—but only for eating, never to photograph.

He has been influenced by still-life paintings, the work of other photographers and what he calls his "own innate sense of how to function profitably."

He shot his quirkily patriotic picture of the rippling American flag because a friend had challenged him to see what he could do with a jelly apple. "Use it as a reflector," was his natural instinct. But what to reflect? He had recently shot a photograph of the flag on a silver background for an insurance company's advertisement, and he had been fascinated by the play of light on the Stars and Stripes. Now he was curious to see what effects the rounded gleaming apple's surface would produce.

The first problem was to decide on the right colour for the apple beneath the coating. In Lieberman's studio kitchen, Andrea Swenson, a home economist, experimented with green, red and yellow apples to see which showed off the translucent crimson sugar-shell best. Yellow won. Next came the problem of achieving a blemish-free surface. Andrea Swenson set to work again.

At last, Allen Lieberman stood a perfect apple on a stand with black flock paper behind it and mounted a small flag—about four inches by five inches (10×12.5cm)—on a piece of diffusion paper, which he placed some three inches (7.5cm) to the left. Test shots made him feel that something was miss-

ing and led him to add another element: a white card to the right with a window cut out of it. Through this, he now projected a single Ascor studio flash, to be bounced back from the opposite side. His premium was the distorted reflection of the window. It took him and his assistant a full day to make about ten exposures.

Although he intended to use the photograph only as a promotion piece, it paid off professionally, becoming both a space advertisement and a poster for the Philadelphia, Pennsylvania bicentennial celebrations.

His flapjacks picture (overleaf) began as a commercial assignment, taken to advertise maple syrup. Here, he wanted to capture the flow—the movement of the thick liquid—on a stack of hot golden pancakes.

Helen Finegold, the home economist, "went to a lot of trouble with the heat of the pan and the timing to obtain the brown lacy pattern" on the pancakes. Lieberman and the two assistants who were working with him went to even more trouble to control the pour of the syrup. They cut out the back of the bottle and inserted a tube through which the syrup was funnelled. At first it splashed and splattered all over the place. While they struggled to tame it, the pancakes became limp and soggy and fresh hot substitutes had to be supplied continuously. Far more serious, the camera lens became so sticky that it had to be sent away afterwards to be rebuilt.

The scene was set up on a piece of glass with a background of black flock paper. Again, Allen Lieberman used only one flash, positioned to the right and sligtly above his subject, and bounced off a number of reflectors. It took a day to set up and to shoot five exposures.

"If that one sounds messy," he says, "it was nothing compared to the chaos I once created when we cut the backs out of fourteen tins of Weight Watchers' liquid and let it flow at the same time into fourteen pitchers rigged up in a row."

ALLEN LIEBERMAN

ALLEN LIEBERMAN
480 Broadway
New York
NY 10002
United States

Major Publications

Work has appeared in virtually every major American magazine, either in advertisements or editorially.

Awards

Art Directors Club: Andy Awards
American Institute of Graphic Artists

TECHNICAL DETAILS

Apple and flag
CAMERA: Plaubel
FILM: Kodak Ektachrome 64
APERTURE: f64
LIGHT SOURCE: Ascor studio flash with
 reflectors

Flapjacks
CAMERA: Plaubel
FILM: Kodak Ektachrome 64
APERTURE: f64
LIGHT SOURCE: Ascor studio flash with
 reflectors

DICK LURIA

DICK LURIA worked chiefly on corporate industrial photography for many years, and his experiences range from searching for minerals by helicopter in the Arctic to shooting in the Columbia space shuttle.

He is a film and museum enthusiast, and both have strongly influenced his style, but the strongest influence is the imagery of other photographers. He admires Ansel Adams for "his stunning shapes and designs, lights and darks" and Jay Maisel for "his rich dramatic tones and hues." He sums up his own skill briefly: "What I can see with my eye, I can put on film."

He also loves food, so much so that he has had to go on a stringent diet in the last couple of years. But he leaves the cooking to his wife.

He has chosen two pictures which are almost identical in subject matter but separated by twenty-five years in time and experience. The first demonstrates an intuitive ability to start with nothing and make things happen. In the second (overleaf), every nuance was impeccably "orchestrated"—to use his favourite word.

In the first, taken early in his career, for a New York restaurant, Maxwell's Plum, for the annual report of the parent company, Dick Luria wanted to convey the feeling of selection and production without actually showing a cooking scene. He, the restaurant owner and a company art director had pretty much agreed the props in advance, but there were limitations; the two work tables, for example, could not be moved.

The opulent still life in the foreground was assembled *ad hoc* from fruits and vegetables in the restaurant stores and lightly sprayed with glycerine. Dick Luria filled his canvas bit by bit, completing it with the positioning of the chef and his aides in their freshly starched uniforms.

He used daylight studio flash, available light filtered at the source and a burn for the warmth that daylight film gives under slight tungsten. Shooting with 35mm, he worked for about an hour and a half, and made forty-six exposures.

When he shot this, he was concerned chiefly with the overall values of the image. To the second, shot only recently, he brought all the expertise he had acquired in the intervening two and a half decades. The concentration now is on lighting and detail.

Many things are important: the light values of the vegetables; the colour of the fish on the cutting board and how it relates to the other items; the steam billowing from the cauldrons; the use of the hanging pots as a frame on the right; the texture of the chef's uniform; his look of competence; the attitude of his hands; his eye contact; the placement of the people in the background.

Dick Luria took this in another New York restaurant, the famous Tavern on the Green, for a book he is preparing on artists and craftsmen. Work began at five in the morning, in an empty kitchen, and everything was moved into the optimum position from the camera's point of view. The chef, a food stylist and a couple of assistants all took part.

Ten studio flash heads were distributed around the shooting area, and Luria used umbrellas, a bounce light and a pale green filter. He also used colour correction filters for the coldness of the high-gloss kitchen. The food was taken out of the refrigerator after the lighting had been set up. The chef put a little vegetable oil on the fish and sprayed the vegetables with water to make them glisten. By then it was nearly opening time and things had to move quickly. The session took some four and a half hours, and Luria made seventy-two exposures.

He does not believe in phoney foods for editorial shoots, but does not object to them for advertising, so long as the client agrees—beaten egg white or shaving cream, for example, to stand in for whipped cream, or dyes to heighten colours.

His photographs often combine people and food, or, even more often, people only, in slice-of-life situations. He does a great many big production shots for advertising, with large casts and large props—automobiles, airplanes, trains—in massive environments that he creates in his studio. He has recently taken to shooting and directing TV commercials.

DICK LURIA

DICK LURIA
5 East 16th Street
New York
NY 10003
United States

Major Publications

Work has appeared in most of the major
American magazines, in annual reports
and corporation brochures, and in TV
commercials.

Awards

Art Direction Magazine: Creativity
 Award, 1981, 1984, 1985 and 1986
Art Directors Club: Merit Award, 1981
CA-83: Communications Art Award, 1983
Graphic Design USA: DESI Award, 1984
Graphic US Award, 1986 and 1987 ˙

TECHNICAL DETAILS

Kitchen scene, chef in profile
CAMERA: Nikon F-2
FILM: Kodak Ektachrome 100
APERTURE: *f*8
LIGHT SOURCE: Dynalight studio flash and
 available light filtered

Kitchen scene, chef facing forward
CAMERA: Hasselblad
FILM: Kodak Ektachrome 64, pushed by $\frac{1}{2}$
 stop
APERTURE: *f*11–16
LIGHT SOURCE: Dynalight studio flash,
 umbrellas, bounce light, 5cc green filter;
 10 flash heads in all, with 6 power packs

DANIEL METTOUDI

DANIEL METTOUDI is given a completely free hand in his editorial work, after preliminary discussions with the editor and the art director to decide on the general approach. His advertising photography, which he finds far less personal or creative, often has to conform to a predetermined layout, but he adheres religiously to a distinctive, close-up, graphic approach for both. This, he says, is his "current" style. Experimentation and inspiration may in the future lead him to change direction.

Food photography represents only one facet of his career. He shoots a variety of still lifes for press relations and commercial clients, and is something of a specialist in beauty products. He has been more influenced by other photographers than by painters.

He is enthusiastic about food, especially shellfish, and he enjoys cooking a wide variety of recipes. He sometimes prepares dishes himself to photograph professionally.

He believes that it is showing the components in tantalizing detail which makes a dish look appealing. He closes in on the ingredients and lets the overall ambience, in a sense, take care of itself. His photographs, of seafood *cassolette*, and of iced cucumber soup (overleaf), both demonstrate his devotion to this style which he underlines with clear, sharp outlines and strong shadows.

Even so unlikely a subject as raw fish seems to bask under this treatment, with rolled fillets of sole, the scallops, the clams and the mussels all glistening appetizingly in the ice-dewed steamer.

Both shots were taken to illustrate dietetic recipes in *Marie France*, the French magazine, and evolved in collaboration with Alain Doignon, the art director, and Regine Signorini, a home economist, assisted by Dominique Nolin, a stylist. The preparation was done in his studio.

He selected and assembled the props himself and set up the compositions on a heavy sheet of ground glass. In the first photo he relied for impact on the intricate shapes and coral-sea colours of the uncooked ingredients. The emphasis in the second was on the embellishments rather than on the chilled soup itself, which, unadorned, would have looked pallidly uninteresting.

He lit both in the same way, with a Quadroflex of 80×80cm (31½ inches square), a spotlight and several strategically positioned reflectors. For the fish he added an 81A filter. He used six flashes for the fish and three for the soup. Each session lasted about two and a half hours and he shot only one exposure each time.

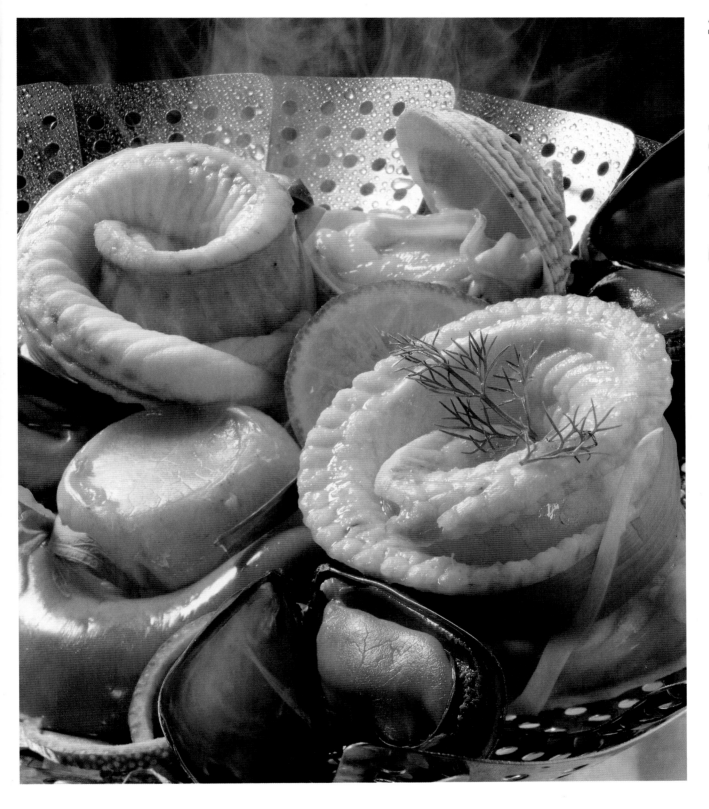

DANIEL METTOUDI

DANIEL METTOUDI
258 rue Marcadet
75018 Paris
France

Major Publications

Magazines:
La Bonne Cuisine
Marie France
Modes & Travaux

Also does photographs for recipe pamphlets, brochures, packaging, press relations and advertising for a variety of clients.

TECHNICAL DETAILS

Seafood cassolette
CAMERA: Sinar P
FILM: Kodak Ektachrome 64
APERTURE: f45
LIGHT SOURCE: Broncolor, Quadroflex
 80×80cm, 1 spotlight and reflectors

Chilled cucumber soup
CAMERA: Sinar
FILM: Kodak Ektachrome 64
APERTURE: f45
LIGHT SOURCE: Broncolor, Quadroflex
 80×80cm, 1 spotlight, reflectors, 81A
 filter

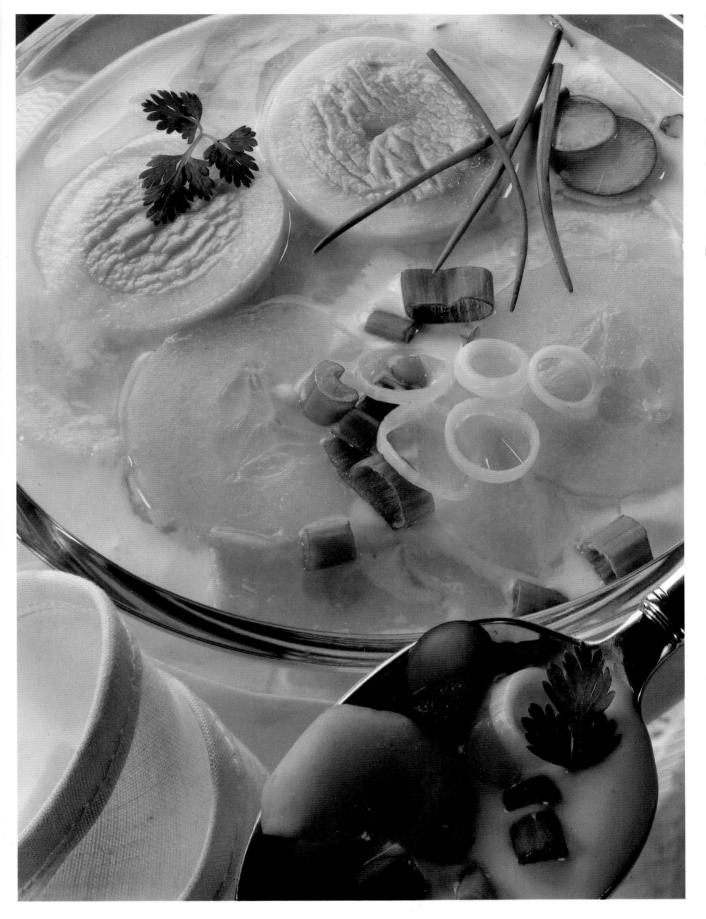

JAMES MEYER

JAMES MEYER has developed his own bold and declarative style through the study of a vast range of photography in books, magazines and galleries. This approach lends itself to advertising photography which represents the bulk of his work, but he also does editorial work for women's magazines, and he is now shooting for a gourmet book on ingredients. Food is his forte but not his entire life; he also does general still lifes and people, especially children. He loves to eat—sometimes in excess, he confesses—but although he likes to cook, he hardly ever does so.

He believes that eight out of ten professional photographers probably share his love of clear simple shapes seen in close-up. To this he adds his own partiality for bright colours—only a few at a time—or, alternatively, for the drama of one predominant colour expressed in varying tones.

His shot of the boiling vegetables illustrates the tremendous impact of the vivid close-up. "A mushroom," he says, "isn't much to look at when you see it from a distance, but it takes on a very interesting form when you're only inches away." He shot the photograph as the cover for a brochure advertising Kempware heatproof glass. and devised it in consultation with the company's art director.

It presented him with a welter of problems: "Too many bubbles. Too few bubbles. Condensation on the glass. Persuading the vegetables to stay where I wanted them. Persuading them not to disintegrate."

To keep the vegetables more or less in position, he stood a small piece of glass vertically about two inches (5cm) from the front of the vessel, and then confined them in the cramped space that resulted. "But I was still in the hands of the god of vegetables," he says. "They kept on bouncing. And the shot kept changing physically." This often happens, he adds, even in less volatile situations, and often to the benefit of the picture.

In this case, the constant changes were an unqualified nuisance. He was determined, for instance, to capture the bayleaf in translucence, and that involved maddening patience and a blistered finger or two. As for the vaporization, his assistant repeatedly coated the steaming pot with an anti-condensation liquid used by opticians, but nevertheless, gathering droplets constantly had to be wiped away.

He lit the shot with flash strip-lights from underneath and slightly to the front. It took him about six hours, and he made eight exposures on large-format film.

The photograph of garlic in a paper bag (overleaf), taken for the jacket of a cook book of French recipes, and evolved in consultation with the publisher's art director, was calm, pleasingly monochromatic and quick to do. It took a couple of hours in all, and six exposures. Meyer is fond of both the warmth produced by the light passing through the paper bag and of the crumpled texture of the bag itself. He achieved the sunlight effect in part by using daylight film with a tungsten spotlight.

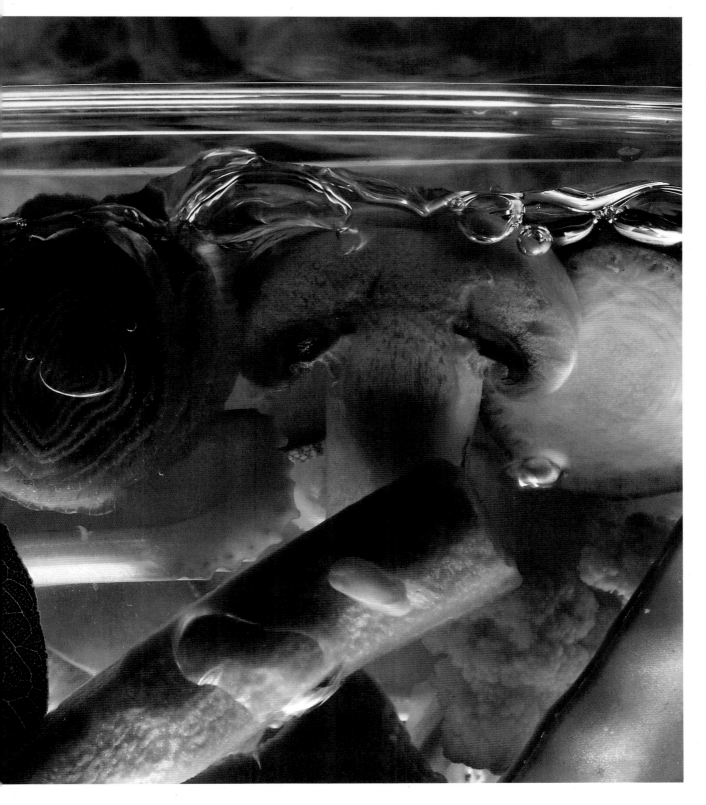

JAMES MEYER

JAMES MEYER
70–71 Wells Street
London W1
United Kingdom

Major Publications

Magazines include:
Taste
Woman's Journal
Woman's Realm

Works mostly in advertising.

TECHNICAL DETAILS

Boiling vegetables
CAMERA: Sinar
FILM: Kodak Ektachrome 64
APERTURE: *f*32
LIGHT SOURCE: Studio Equipment flash strip-
 lights

Garlic in bag
CAMERA: Sinar
FILM: Kodak Ektachrome 64
APERTURE: *f*11
SPEED: 5 seconds
LIGHT SOURCE: Bark Strand Harmony 22/
 40 tungsten spot directed through paper
 bag

James Meyer

KIM MILLON

"Food is a basic and essential part of everyday life," Kim Millon maintains, "not something created and artificially enhanced in a vacuum. I think that it's important to take it out of the studio and put it back in its context. I don't feel that an environment can be synthetically achieved with props and lighting techniques. It is a natural reflection of the food itself."

Kim Millon and her husband Marc are a writer-photographer team who keep busy with commissions for books and articles on travel and architecture as well as on food and drink. They recently completed a magazine assignment on Mexican food, went on to France for a book about wine, and will soon take off for Korea.

When she can, Kim researches in advance and works out her compositions before they go on location. Fine arts studies at university, where she specialized in photography and print-making, have made her keenly conscious of composition, an awareness which she brings to all her work.

Cooking is as much a part of her life as her cameras. She prepares meals for fun for friends—a wide range of dishes from many lands, stemming from their assignments. She tests all the recipes that appear in their books and she herself cooks almost every dish that she shoots professionally.

She insists that everything in her photographs—the setting, the lighting, the food itself—be as close as possible to the way nature made it.

By shooting on location, she gives her subject an authentic background, thus injecting a telling note of actuality. For the same reason, she never adulterates the food in any way to make it more photogenic; nor does she indulge in camera trickery.

Both the photos she has chosen exemplify her anti-artifice creed. They were taken for a book, *The Taste of Britain*, on which, as always, she and Marc collaborated, and which they invariably do. He knows where the editorial stress should lie; she—because she also devises the recipes—knows what the food must illustrate.

The photograph of Cheshire blue cheese (overleaf), she says, "had to be informative as well as atmospheric." It had to show the blueness of the cheese, its solid shape and the texture of the rind. "It is a natural product of the dairy and I wanted to emphasize this by shooting it as naturally as possible on a midsummer's day at the Cheshire farm that produces it."

The couple spent a morning touring the dairy to learn how the cheese is made before they set up the shot in the garden. "It is essential to get as much technical background and information as possible," Kim Millon says, "even if it never shows in the photo." The farmer's wife helped them to assemble the props from around the farm. All, the plate and jug, the milk churn, the freshly cut delphiniums were chosen to bring out the distinctive blue of the cheese.

She shot entirely in natural light without the help of flash, fill-ins or filters. The session lasted about five hours and she made five exposures, which she took, as she usually does, at half-stop intervals. To produce more colour saturation in the finished transparency, she slightly underexposed, another of her usual practices.

The informative element, she says, was less important in her second shot since most people in Britain know what a cream tea looks like. On the other hand, the book was also to be published in the United States, so she could not ignore this aspect. What she wanted to do most, however, was "to rekindle the nostalgic memories of summer holidays in the West Country. In the text, Marc writes descriptively about my memories of childhood summers in Devon. I was almost illustrating his prose."

Again she used no artifice. "This is exactly the way cream teas are served at the Southern Cross tea-shop in Newton Poppleford," she says. She accentuated the rich texture of the clotted cream and the crumbliness of the scones by shooting late in the afternoon when the sun was low, but again—no camera jiggery-pokery!

Four of the staff helped the Millons to set up the scene, using the tea-shop's regular china. Shooting lasted about two hours and Kim produced five exposures, after which she and Marc sat down to enjoy the tea they had just photographed.

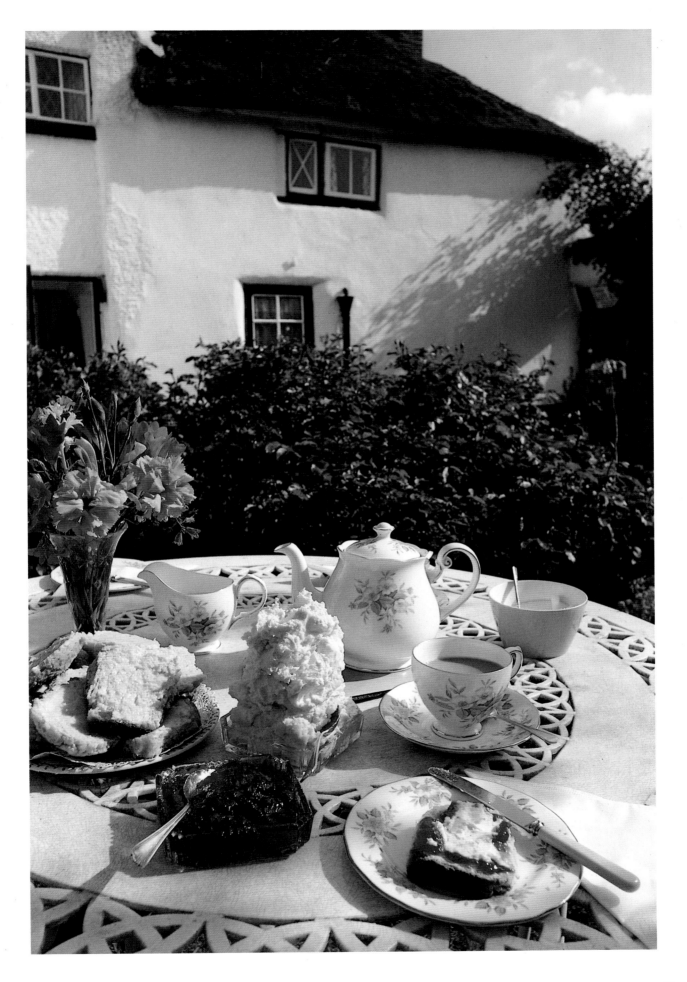

KIM MILLON

KIM MILLON
Quay Cottage
Ferry Road
Topsham
Devon EX3 0JJ
United Kingdom

Major Publications

Books:

The Taste of Britain and Ireland (Marc
Millon), Webb & Bower, Exeter, 1985;
Salem House, Topsfield, 1985

Wine & Food of Europe (Marc Millon),
Webb & Bower, Exeter, 1982;
Chartwell Books, 1982; Treasure
Press, 1984

Magazines including:
SLR Photography
Taste
You

TECHNICAL DETAILS

Devon cream tea
CAMERA: Nikon FM
FILM: Kodachrome 25
APERTURE: *f*22
SPEED: $\frac{1}{60}$ second
LIGHTING SOURCE: daylight

Cheshire blue cheese
CAMERA: Hasselblad 500 C/M
FILM: Kodak Ektachrome 64
APERTURE: *f*8
SPEED: $\frac{1}{25}$ second
LIGHTING SOURCE: daylight

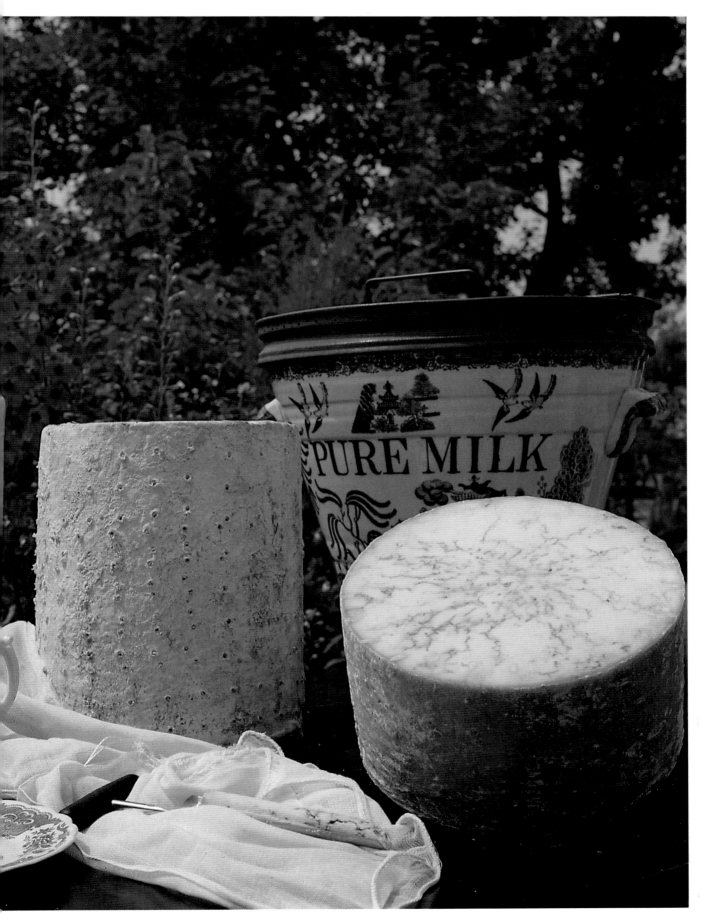

Kim Millon

PURE MILK

JULIAN NIEMAN

JULIAN NIEMAN brings to his craft a love of pictures of all kinds—photographs, drawings, paintings, films. "Every picture that I see," he says, "tends to influence me one way or another. I can't pick out a single photographer or painter as a special influence." Food represents only one facet of his work. He also photographs interiors and still lifes, architecture and people.

He has an insatiable curiosity about food, likes to try new things and enjoys eating almost anything that he has not had for a while. He is a family man and sometimes cooks simple dishes at home, but he wouldn't dream of trying to prepare anything to photograph. He has too much respect for the professional home economist: "I could never meet the high standards of presentation that are required."

He chose his pair of pictures for a highly subjective and creative reason. "I have been able to put more of me into these two than I can into a lot of my work," he says. Like most professionals he is often restrained by the inhibiting strictures of commercial demands. Whenever he gets the chance he revels in the comparative luxury of personal expression.

He shot both pictures for the British magazine *A la carte* shortly after it began publication. At that time, he says, "they were encouraging photographers to be picture-makers rather than straightforward technicians."

The staff then, Jenny Greene, the editor, Nicky Hughes, her assistant, and Michael Boys, the photographic consultant, used to establish a concept for a picture, "but they never fixed it in concrete before talking it over with the photographer. They were receptive to our ideas too. And they were always willing to experiment."

The fantasy of the fish in the bath of marinade (overleaf) developed in just this way, with everyone's imagination encouraged to run rampant. A model-maker was commissioned to build a mackerel-sized acrylic bath, and Julian Nieman and his assistant put all the intangible ideas together to create a compelling and amusing photograph. "I enjoy excursions into fantasy," he says, "especially if they illustrate something else as well."

The back wall is white card, with windows cut out by the photographer and draped with netting. The foliage in the miniature vases is parsley. The floor is paper covered with clear plastic. Frances Bissell, the writer of the accompanying article, which dealt with the steeping of foods in a variety of flavour-inducing liquids, supervised the concocting of the marinade.

It took a long morning's work—from nine to about one-thirty—to produce about a dozen exposures lighted by Bowens flash.

His second photograph, an illustration of *cœurs aux abricots*—heart-shaped apricot profiteroles—grew out of a pictorial idea that had been conceived for the marinading piece, but which in the end had not been used.

He is particularly pleased with this one, because a lot of craftsmanship and technique were demanded to produce something that looks so simple. A drinking glass separates the bottom dish from the table, and a second separates the two dishes from each other. Mirrors were placed under both dishes to enhance their gleam.

A stylist obtained the dishes and the roses. The profiteroles were prepared in the studio kitchen by a home economist. Julian Nieman worked out the placement and the lighting. Again, he used Bowens flash, and made some sixteen or eighteen exposures in half a day. The only problem was that the *cœurs* began to look a little dull after ten minutes or so. But there were ample supplies (all delicious!) to keep popping in front of the camera.

Julian Nieman

JULIAN NIEMAN

JULIAN NIEMAN
c/o Susan Griggs Agency Ltd
17 Victoria Grove
London W8 5RW
United Kingdom

Major Publications

Book:
*Hampton Court: the Palace and the
People* (R. Nash), Macdonald,
London, 1983; Salem House,
Topsfield, 1984

Magazines:
A la carte
Connoisseur
Food & Wine
Panam Clipper
Reader's Digest
Tavola
Telegraph Sunday Magazine
Travel & Leisure

He also does corporate work for various
London and New York design groups.

Awards

Association of Fashion Advertising and
Editorial Photographers Silver Award:
for a landscape photograph (1987)

TECHNICAL DETAILS

Cœurs aux abricots
CAMERA: Cambo
FILM: Kodak Ektachrome 64
APERTURE: *f*32
LIGHT SOURCE: Bowens flash

Fish in bath
CAMERA: Cambo
FILM: Kodak Ektachrome 64
APERTURE: *f*16
LIGHT SOURCE: Bowens flash

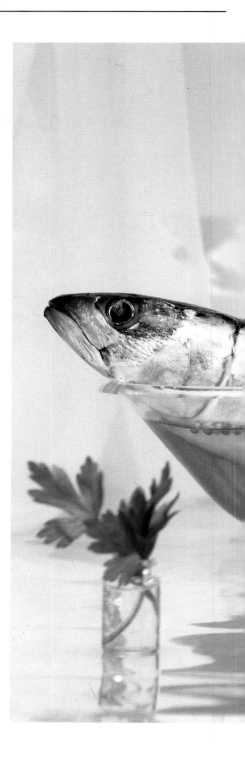

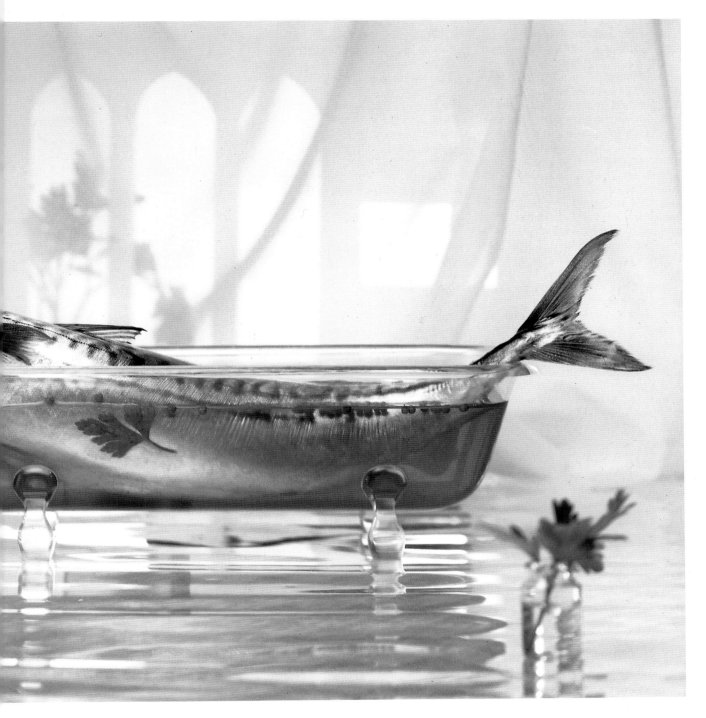

BRADLEY OLMAN

BRADLEY OLMAN's work appears regularly in virtually every American women's magazine and he does all sorts of "lifestyle" photography—nature, interiors, fashion, consumer goods, still lifes. He has been influenced by Sarah Moon's misty, grainy, romantic photographs and by Richard Jeffry's naturally lighted Old Master type still lifes.

He prefers hearty peasant food to gourmet dishes, and he likes to cook, indoors and out, especially James Beard's recipes.

He says that although the food he shoots may not necessarily be real, his photographs always are. He doesn't believe in technical trickery and he likes his lighting to be as natural as possible. The edibles, on the other hand, may be totally *in*edible, so long as they look right to the camera.

His tableful of luscious-looking ice cream is a fine example of phoney food at its appealing best. He took it for *It's Me*, an American magazine published by the Lane Bryant department stores which cater for the "larger woman" and it illustrated a number of recipes for diet ice cream.

All the trimmings are real—the meringues, the fruit and the berries, the cookies, the syrups. But every dish of ice cream is an artfully coloured, flour-and-water fake. "To make it all look thick and rich enough took forever," Olman says. "We had to get the right texture and put the ridges in. And because the 'ice cream' wasn't cold, the syrups ran more than we expected."

He chose this shot because of its very difficulties. "It's an example of a hard product to work with, a great many props, flash lights and a lot of problem-solving," he says. He worked on it with his two assistants, Suki Cannon, a food stylist, and the magazine editor. "It was a group effort." They spent a full day on the shoot, much of which was devoted to the positioning of the various dishes. Because the photograph was to be accompanied by recipes, everything had to be clearly visible and graphically explanatory.

He used all flash, overhead bank light with bounce fills and shot two rolls of thirty-six exposures each because the magazine wanted extra copies.

His second photo (overleaf) for a cookbook on American country inns was almost effortless. An illustration for lobster and fish bisque was to have been an indoor, table-top picture. But Olman, arriving on location in eastern Maine, saw the dog, the lake and the chairs, and decided that the simplicity and beauty of the outdoor setting would give the rather plain soup just the lift it needed. "It was a matter of being in the right spot at the right time," he says. He seized the opportunity.

The cook at the inn, the editor and the food stylist all agreed. Shooting only with natural light and some bounce cards, he finished the entire job—one roll of fifteen exposures, bracketed—about twenty minutes after the food was set out.

A few extra chunks of fish and lobster had been added to the soup and raised slightly above the surface by the stylist, so that they could be seen by the camera. They were also seen—and sniffed!—by the dog, who would rather have lapped it all up than pose beside it. He was gently discouraged.

Although the first shot required studio lighting and the second obviously did not, they both demonstrate Olman's commitment to the use of a soft overall light source rather than an array of spots, grids and other extras. "The drama," he feels, "is in the food and not in the lighting."

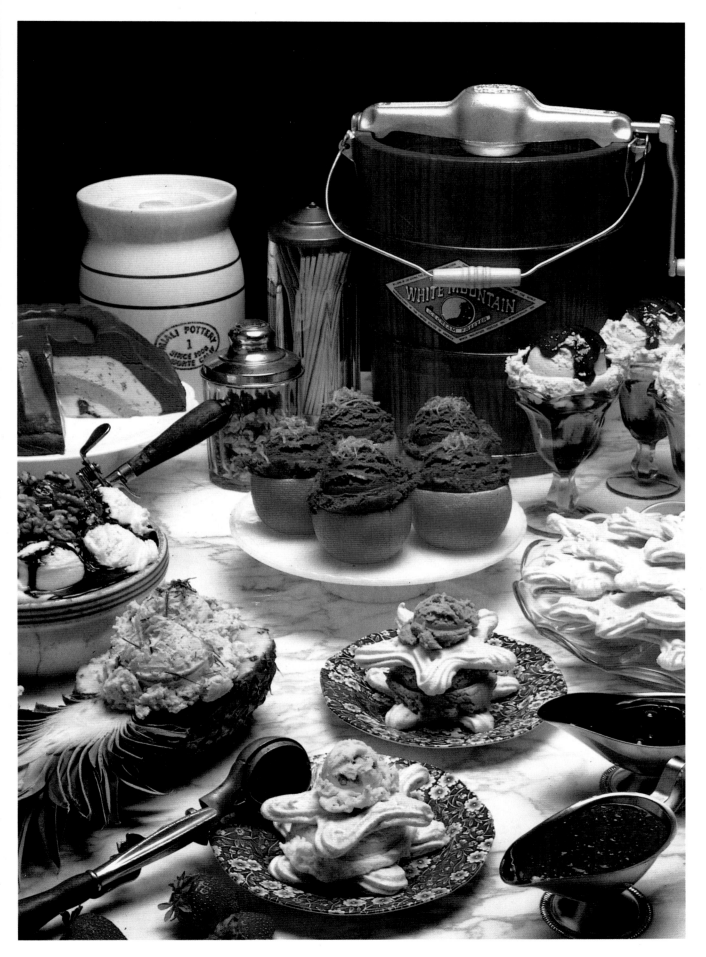

BRADLEY OLMAN

BRADLEY OLMAN
15 West 24th Street
New York
NY 10010
United States

Major Publications

Work has appeared in virtually every American women's magazine.

Awards

Garden Writers of America Photography
 Award

TECHNICAL DETAILS

Dietary ice cream
CAMERA: Nikon
FILM: Kodachrome 25
APERTURE: *f*16
LIGHT SOURCE: all flash, overhead bank light
 with bounce fills

Lobster and fish bisque
CAMERA: Bronica
FILM: Kodak Ektachrome 100
APERTURE: *f*8
SPEED: $1/500$ second
LIGHT SOURCE: natural light with reflectors

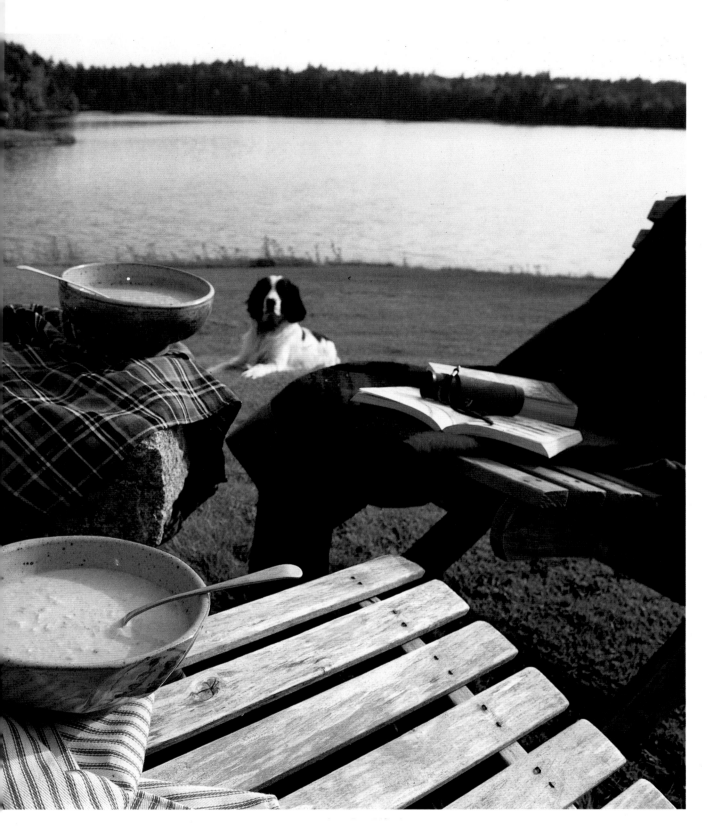

Bradley Olman

TOM RYAN

TOM RYAN divides his time fairly equally between editorial and commercial work, doing still lifes and product photography of all kinds, including automobiles. He sometimes makes his own sketches of compositions in advance, but more often he is provided with layouts by his art directors. Irving Penn has been his most important influence and inspiration.

He loves food, especially Italian and Mexican and as a cook his speciality is man-sized Texas breakfasts. He flew in the face of convention with his sharp-lined still life of Mexican food. Its bold blackness and crisp graphic design separate it entirely from the stereotypical "south-of-the-border" shots with their trademark serapes, straw hats, cacti and terracotta tableware.

He had been commissioned to produce "something different" for the annual report of Pancho's Mexican Buffet, a Dallas restaurant. The art director liked the result. The client did not and asked to have it re-shot in the traditional way. None the less, the original remains one of Ryan's favourite promotional images.

It was set up on a black laminate surface with black props to make the food "jump out." Helping him were his assistant: Lee Stanyer, a food stylist; Kat Hughes, a prop stylist, and the art director. The client looked on. They cheated a bit to produce enchilladas—usually a rather sloppy dish—that were round, firm and uniform in size. Each tortilla was wrapped round a raw hot dog and only the ends were stuffed with the meat and cheese fillings.

Lee Stanyer brought into play a contraption of her own invention to keep the melted cheese on the middle and top three from developing a skin, without liquefying or disarranging the neat squiggles of sour cream on the tomato sauce that covered the bottom three. She attached a hose to an ordinary vegetable steamer and aimed it only at what had to be kept hot. The chalupas on the plate in the foreground were also glamorized by being heaped up much more neatly than usual and the olives were lightly coated with oil to make them gleam.

Tom Ryan shot with one flash bank—five feet by five feet (1.5×1.5m)—placed above and slightly behind the set-up. A five-hour session produced five exposures on large-format film.

His second photograph (overleaf) is also characteristic of his part of the world. It illustrated an article in *Texas Monthly* magazine on grazing, a growing trend which involves dining on small portions of a variety of culinary pleasures. Some of the dishes—fruit tart, smoked salmon pizza, miniature pastries, salads, quail flanked by quails' eggs sunny side up—were prepared by the chefs of four different Dallas restaurants. Others were prepared in Tom Ryan's studio kitchen by Cynthia Jubera, the food stylist.

The props were assembled by Debra Allen, and the emphasis this time was on realism. Distinctive plates suggested the characteristic atmospheres of the different restaurants. The surface is a piece of rough-hewn sandstone and Ryan exaggerated its natural texture by placing one of his two banks of lights at a low angle, only slightly above the setting and to the left, with no diffusion. He added a warming gel to simulate sunshine and to enhance the food's appetite appeal. The second light was directly overhead, to create highlights. Studio time was three hours for five exposures.

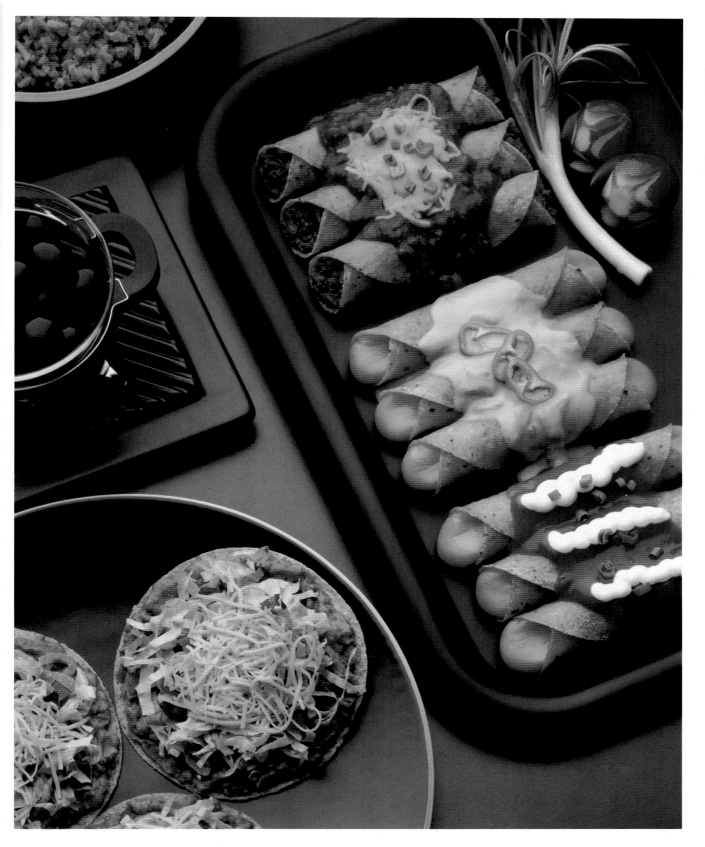

TOM RYAN

TOM RYAN
1821 Levee
Dallas
Texas 75207
United States

Major Publications

Magazines:
Art Direction Magazine
Better Homes and Gardens
Essence Magazine
Metropolitan Home
Sports Illustrated
Texas Monthly
Time

Work is also used by various advertising clients.

Awards

Dallas Society of Visual
 Communications
TOPS Award: southwestern USA, for
 advertising
Art Direction Magazine Creativity Award
Direct Marketing ECHO Award

TECHNICAL DETAILS

Mexican food

CAMERA: Sinar
FILM: Kodak Ektachrome 64
APERTURE: *f*45
LIGHT SOURCE: 1 flash bank from above and
 slightly behind

"Grazing"

CAMERA: Sinar
FILM: Kodak Ektachrome 64
APERTURE: *f*45
LIGHT SOURCE: 2 flash banks, one slightly
 left above, the other directly above; a
 warming gel

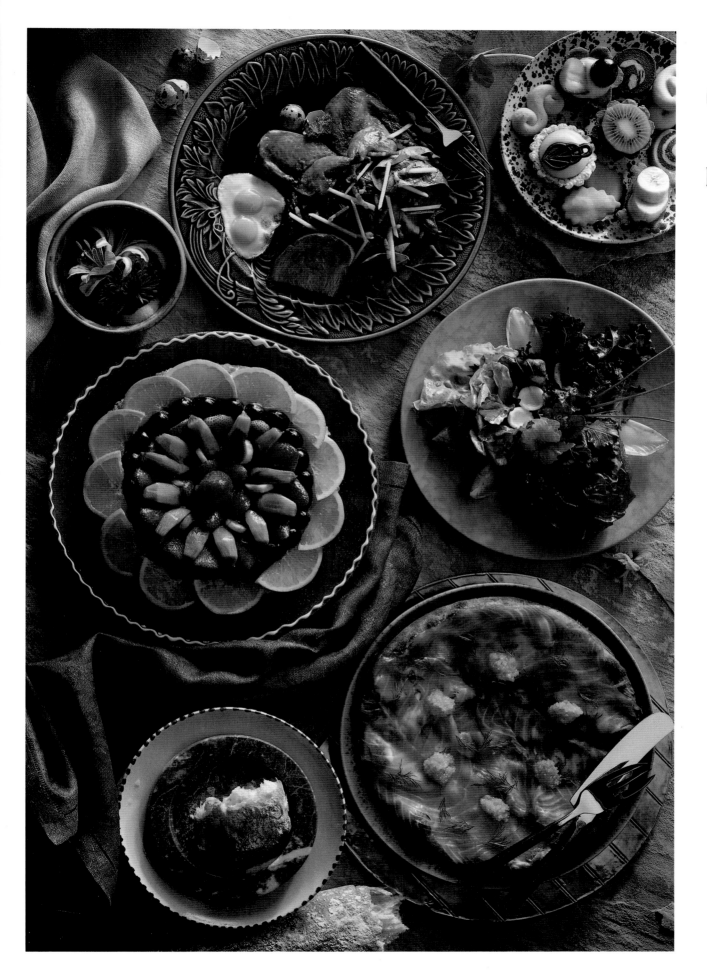

Tom Ryan

MAX SCHNEIDER

MAX SCHNEIDER is a strong believer in specialization and seldom photographs anything except food. He thinks that a professional should aim to be the best in his own field and let the others get on with being the best in theirs. "A client—rightly—doesn't turn to me for fashion shots," he says.

An experimental diner, he will try almost anything, but he confines his own cooking to fairly basic dishes which are, however, always deliciously flavoured. Here taste is paramount. "I don't eat the meals that are prepared to be photographed," he says, "and I don't photograph the meals that are prepared to be eaten."

He feels no need to be looked upon as an artist. "Being an expert craftsman is difficult enough." When a client asks him to bring a certain atmosphere to a picture, he sets about it in a workman-like way, with no artistic pretensions. He wants his photographs to be beautiful, of course—"But putting them into a handsome frame and scrawling a signature at the bottom doesn't transform them into works of art."

He believes that the true success of a photograph rests in how effectively it establishes the aura that was demanded in the brief. The two chosen shots respond, in their totally different styles, to the commissions he was asked to carry out.

He wanted the bread picture (overleaf) "to radiate a certain warmth." He took it to illustrate an article on baking bread at home, which appeared in *Libelle*, a Belgian women's magazine. It was later used as the cover for *Ambiance Culinaire*, a food magazine. The concept was evocatively old-fashioned, suggesting a pleasing nostalgic past when there was plenty of time for cooking and baking.

To convey the feeling of the country, Max Schneider devised what he describes as "a rather rough, apparently careless composition"—in no way formal or stylized. He and the editor had agreed on the contents and the general layout. Establishing the mood was left to him, with the help of an assistant.

"To me," he says, "food means warmth, comfort, cosiness, dark tones, natural colours, soft shadows." That is virtually the description of this shot.

There is a slight irony in the fact that the "home-baked" breads were all bought from the local baker. The accessories for this, as well as for his second photo, came from his own collection of props.

The fish shot is in complete contrast to the bread. It was also taken for *Libelle* and it illustrates a recipe based on a sophisticated balance of fine fresh tastes—*goujons* of sole, Belgian endives and limes, which demanded a firm and far more stylized approach. "Almost cool," says Max Schneider. The two-star chef, who was the subject of the article, prepared the dish in Schneider's studio kitchen, and the editor of the magazine was on hand, as well.

Lighting was in a sense the key ingredient in both these photos so Schneider likes to shoot against the light because this provides structure, but the total effect, he feels, is often too hard. To counteract this in both cases, he created soft back-lighting.

He softened the bread picture further by lighting through thick, white, translucent Plexiglas. To tone down the fish he used a softbox (Hazylight) over three feet (1m) square; but at the same time he reflected it against the black tiles on which the dishes stand, to achieve a harder, fresher look.

He shot both with the shutter open, using twenty-five flashes of Broncolor studio flash for the bread, and twelve for the fish.

In the first, his preoccupation was largely with giving roundness and texture to the bread. In the second, it was to distinguish between the slight and subtle colour differences of the ingredients and the porcelain—to maintain the *ton-sur-ton* delicacy without losing the structure. He spent four to five hours on the bread and about two on the fish. After he had calculated the number of flashes for each, he shot a number of times, varying the diaphragm opening by a half to a full stop, both lighter and darker.

He has no objection to using artificial colourants for emphasis, but he had no need to do so for these shots. Nor is he concerned with how the food tastes. The *goujons*, for example, were not even seasoned. If what he photographs turns out to be edible, that is pure coincidence. He asks the people who cook professionally for him to concentrate on one thing: "How does it look?"

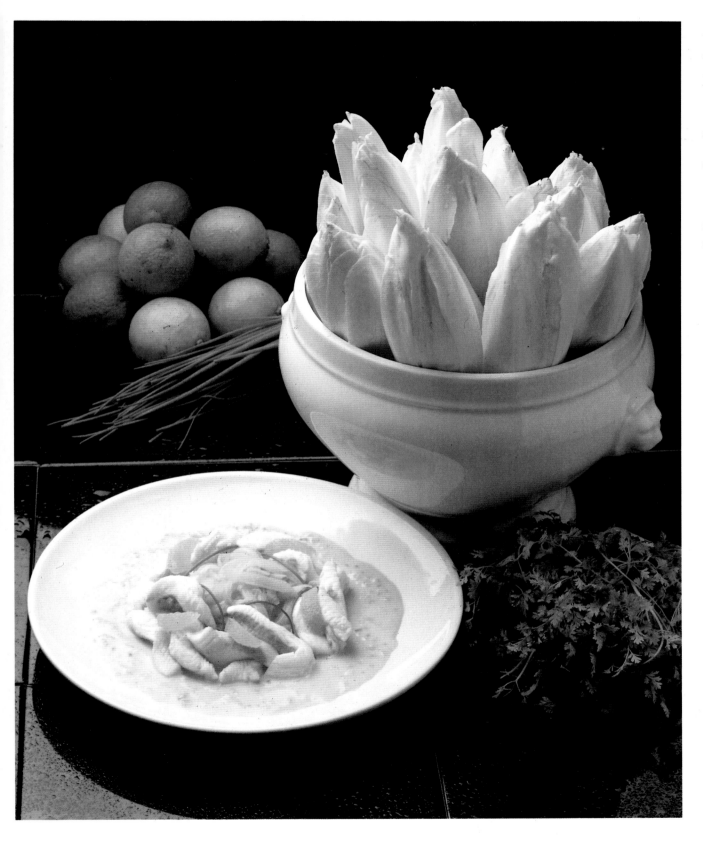

Max Schneider

MAX SCHNEIDER

MAX SCHNEIDER
Vinkendam 6
B 2750
Beveren
Belgium

Major Publications

Magazines:
Ambiance Culinaire
Knack
Libelle
Meat-Contact
Uit

Work has also been used in numerous food books.

TECHNICAL DETAILS

Fish
CAMERA: Sinar P
FILM: Kodak Ektachrome 64
APERTURE: f32
SPEED: open-shutter technique; 12 flashes
LIGHTING SOURCE: Broncolor studio flash;
 divides 7,500 joules among 2 Hazylights,
 6 regular heads, 1 cumulight and 1
 spotlight

Bread
CAMERA: Sinar P
FILM: Kodak Ektachrome 64
APERTURE: f32
SPEED: open-shutter technique; 25 flashes
LIGHTING SOURCE: Broncolor studio flash;
 divides 7,500 joules among 2 Hazylights,
 6 regular heads, 1 cumulight and 1
 spotlight

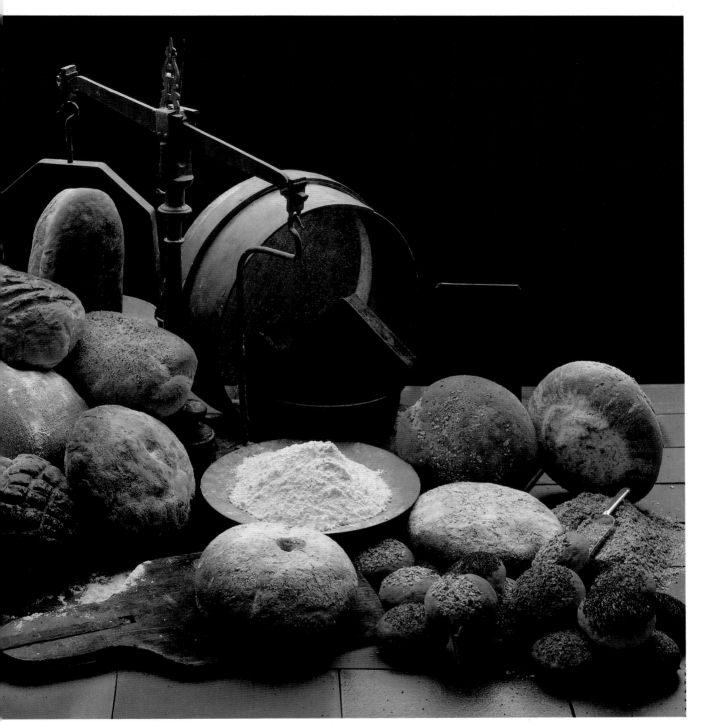

SARA TAYLOR

SARA TAYLOR is a young photographer only in her twenties, who is bringing a young, fresh, light approach to the art of shooting food. While she greatly admires the moody, realistic photographs whose style echoes the glorious still-life paintings of two hundred years ago, she wants to express herself in the vigorous, clear-cut, graphic terms of today.

Her career has soared in no time, bringing her numerous editorial and commercial assignments, both in food and in other fields, including still lifes for design companies and packaging.

Her favourite foods are Italian and French, both for eating and cooking. She sometimes shoots dishes that she has prepared herself, but never for commercial work.

Both the pictures on these pages were non-commissioned shots, which she made to test the validity and flexibility of her technique. She is pleased with the results, largely because of the simplicity of composition and of lighting.

The background for the pearl-hued bottle of clear water with salad and lemon, was a sheet of hand-made translucent paper which she back-lit with a single "blond" tungsten light. The foreground was a glass shelf wrapped in the same paper and lit from the right-hand side with a "redhead." She warmed the scene slightly with an 81B filter behind the lens and toned down the highlights with a soft fill.

Her background for the mosaic of spices (overleaf) was another hand-made paper, strongly textured with a hatching of white threads. On this she laid an ordinary paper grocer's bag, which she ripped open. The only light source was a tungsten "blond" behind the paper, bounced off a white card. She used gold cards to reflect the light back on to the spices and, again, a soft fill to subdue the highlights and to soften the texture of the paper, which the back-lighting had exaggerated.

She assembled, arranged, lit and shot both photographs entirely on her own. She took them in the London studio of Robert Golden, the well-known stills and television photographer, for whom she worked as an assistant before setting up independently in 1986–87. He has been not only her mentor, but a major inspiration.

She finds food and all its ingredients beautiful in its natural state and she will never resort to tricks or artifice to distort the truth of the real thing. Hers is a fortunate blend of creativity and cautious systemization. She invariably thinks out her compositions in advance, makes pencil sketches before shooting day and usually sticks pretty rigidly to her plan—"Unless I suddenly come up with a better idea on the day itself."

SARA TAYLOR

SARA TAYLOR
Unit 21
Industrious Studio
Perseverance Works
38 Kingsland Road
London E2
United Kingdom

Major Publications

Books:
Casseroles Book (Mary Cadogan),
 Woodhead Faulkner, Cambridge
Food & Drink Book, BBC Publications,
 London, 1985
Food for Friends (Sophie Grigson),
 Ebury Press, London

Magazines:
A la carte
Cosmopolitan
Country Living
Expression
Good Housekeeping
Observer Magazine
Signature
Sunday Telegraph Magazine
Woman's Journal

The design companies for which she
has worked include Lewis Moberly,
Pethick & Money, and Michael Peters
& Partners. Advertising clients include
Dulux, Asda Wine, Johnson & Johnson
and Essential Body Oils.

Awards

Most Promising Editorial Photographer
1986: nominated by Mike Lackersteen
for the Creative Futures Exhibitions at
the Hamilton Gallery, Mayfair, London

TECHNICAL DETAILS

Bottle and lemon
CAMERA: Sinar
FILM: Fujichrome 64, tungsten balanced
APERTURE: *f*64
SPEED: 30 seconds
LIGHT SOURCE: "blond" tungsten back-
 lighting, "redhead" from right, soft fill,
 81B filter

Spices
CAMERA: Sinar
FILM: Fujichrome 64, tungsten balanced
APERTURE: *f*64
SPEED: 1 minute
LIGHT SOURCE: "blond" tungsten bounced
 off white card, gold cards for reflection,
 soft fill

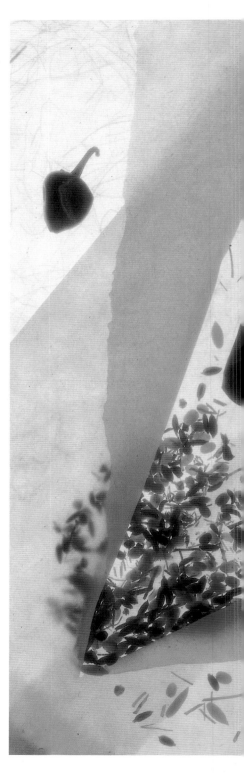

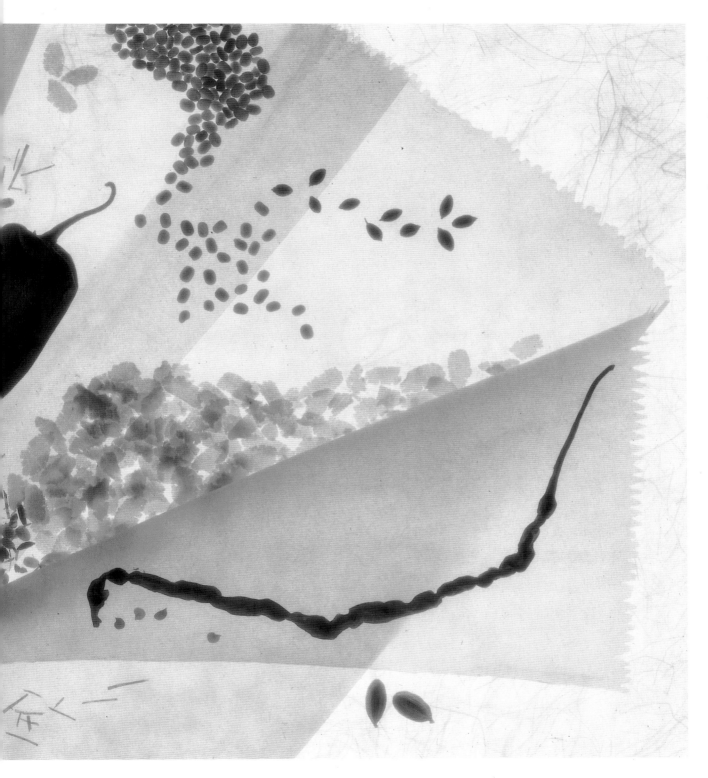

TESSA TRAEGER

TESSA TRAEGER subscribes to a theory enunciated by the late Joseph Beuys, the German sculptor who was co-founder of the Green Party, that certain inanimate objects have an energy and a tension that make them photogenic—for instance, sea salt, or a glass jug filled with water. Tessa Traeger often finds such tension (she calls it "passion") in objects that have a personal meaning for her: a porcelain bowl that she brought back from China, a ledge of weathered slate or a faded wall in her old Devon farmhouse.

She was among the first professionals to take food photography seriously. "When I began, back in 1975," she says, "it was considered very downmarket, and the pictures were mostly pretty dreadful—everything shining with glycerine. But painters have always taken food seriously; so why shouldn't we? It isn't a 'little' subject. You can find out more—and more quickly—about the history and culture of a nation by looking at its food than in any other way. Food is a direct expression of a country's spirit."

Several times a year she and Arabella Boxer, the cookery writer, prove this on in-depth foreign explorations for the British edition of *Vogue*. In addition, they collaborate on a regular monthly cookery feature for the magazine. Tessa Traeger also freelances for a variety of other publications on a variety of other subjects, from gardens to portraits of famous people.

She likes to cook, especially in Devon, where she buys local produce in the country market—beautifully fattened fowl, delicious pork, brawn, farm-ripened cheeses. "The pictures I take in Devon are my most authentic—a cockle wet from the sea, an onion or a potato with the black earth clinging to it—they're basic and true."

She often takes pictures for fun, often of food. But they have a way of appearing in print months later, in projects she had never anticipated.

She has chosen two entirely dissimilar photographs to represent her work, one starkly simple, the other overtly romantic. And both styles are uniquely her own.

She first became famous for her inventive food photographs in which she incorporated oil paintings or other works of art, as in the charming scene shown here. It is a fanciful concept that, for a time, became almost her trademark. She evolved it for what she calls a completely "banal" reason: "Most magazine pages are vertical, but food tends to be horizontal. The idea was a way to fill the top half of the page."

The notion appealed both to editorial and to advertising art directors, and she employed it to illustrate numerous books and features. This example appeared in an advertisement for electrical kitchen equipment in 1980. She particularly likes the unity between the three-dimensional objects in the foreground and the painting in the background, *One of the Family*, by F. G. Cotman, the nineteenth-century artist. The effect is that of an uninterrupted panorama, with even the creases in the two tablecloths blending imperceptibly.

She had a completely free brief for this, setting it up in her London studio with the help of an assistant and Dinah Morrison, a professional cook. It took a day to prepare the set and another to take the photograph. She shot twice—once with the pies untouched and once after they had been cut. This was an insurance policy, as it is never possible to predict what the inside of a dish will look like. She took ten sheets.

Her second photograph (overleaf), an unadorned study of wholewheat pasta set against a crumpled paper bag, which also appeared in British *Vogue*, is typical of the work she is doing today. Its feeling is as far from romanticism as, say, a Mondrian from a Titian.

She devised it together with Patrick Kinmonth, the former arts editor of *Vogue*, and they arranged it in her London studio with the help of Kate Gadsby, her assistant, who also cooked the pasta to the right degree of *al dente* texture for malleability. Tessa Traeger spent a day on the photograph and took about twenty exposures.

She evolved her new technique gradually, by way of another invention of hers: stylized collages made up of foodstuffs—a mosaic of peas, beans and lentils, for example, or a pattern of herbs. She attributes this innovative "minimal" approach to Kinmonth's influence. "I thought," she says, "that people expected a picture to contain more. Patrick gave me the confidence to strip a photo down to its essentials—simplicity based on good design." She recently took a close-up of a single cabbage leaf showing every vein and crinkle, to illustrate a piece on fibre in food.

She and Patrick Kinmonth are completely at one about the "philosophy" of a photograph. Both abhor the "arty" and the "precious." Both believe in the beauty of raw products and in food as a document, not an arrangement.

"I would far rather shoot in a shabby Turin *trattoria* two hundred and fifty years old, where everything is honest," she says, "than in a faddy *nouvelle cuisine* restaurant. The *trattoria* may be the most un-chic place in the world, but it will serve you a proper *bollito misto* or a perfect *risotto* with white truffles that the dog dug up that day."

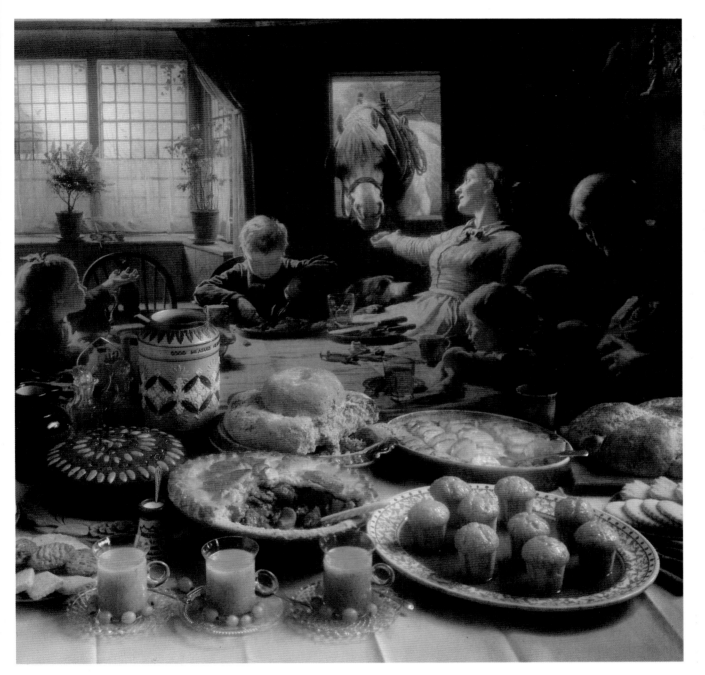

TESSA TRAEGER

TESSA TRAEGER
7 Rossetti Studios
72 Flood Street
London SW3
United Kingdom

Major Publications

Farmhouse Cookery (Reader's Digest),
 Reader's Digest, 1980
Mediterranean Cook Book (Arabella
 Boxer), Dent, London and New York,
 1981
Sunday Times Complete Cook Book
 (Arabella Boxer), Weidenfeld &
 Nicolson, London, 1983
Vogue Food Diary, 1978
Vogue Summer & Winter Cook Book
 (Arabella Boxer), Mitchell Beazley,
 London, 1980; *The Bon Appetite
 Summer and Winter Cook Book*,
 Knapp Press, Los Angeles, 1980

Awards

Dada Silver Award for Food Photography
 1979

TECHNICAL DETAILS

Panorama with painting
CAMERA: MPP
FILM: Kodak Ektachrome 64
APERTURE: *f*45
LIGHT SOURCE: Elinchrom flash

Pasta
CAMERA: MPP
FILM: Kodak Ektachrome 64
APERTURE: *f*8–11
SPEED: 1 second
LIGHT SOURCE: daylight with 81A filter to
 overcome blue cast

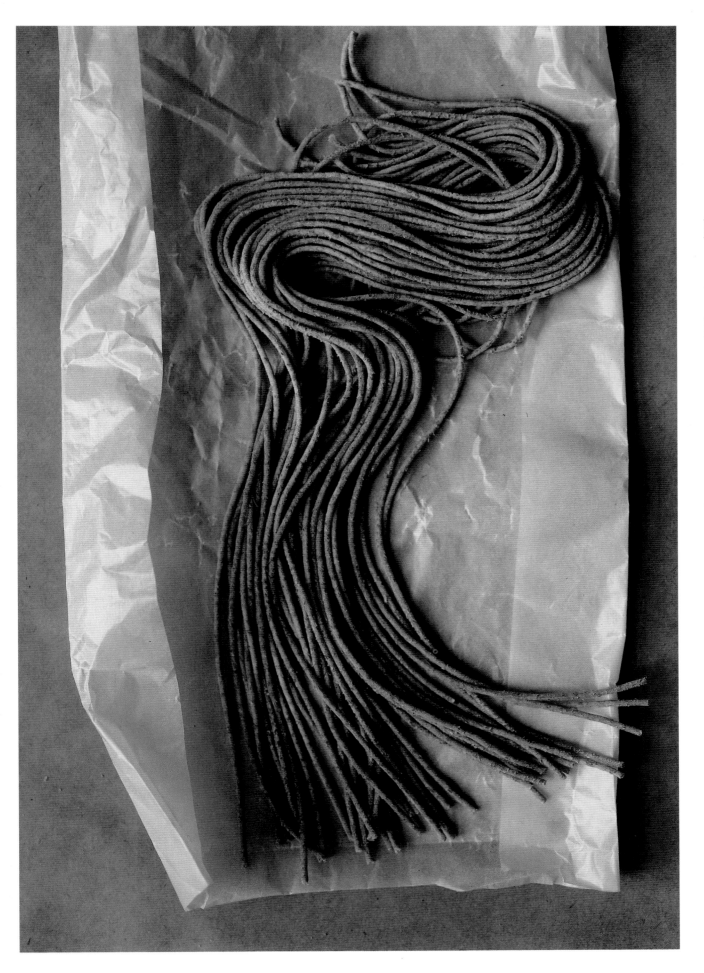

GIANNI UMMARINO

GIANNI UMMARINO insists upon honesty and reality in all his work—portraits, interiors, still lifes in general—as well as in food. He is himself an enthusiastic cook and something of a specialist in fried dishes, but he is far from expert enough to concoct anything for the camera. It is up to his pictures, he says, and not to his kitchen skills, to evoke the subtleties of taste and flavour.

He calls on such words as "passion" and "instinct" to express his approach. He chose the two photographs he shows here because "they represent emotional moments in my work—because they convey feeling and atmosphere." He produced them both, in an entirely instinctive way, responding to the colours of his subject matter and to its intrinsic appeal to the appetite.

The first shot was taken on the terrace of the Hotel Danieli in Venice, looking out across the dreamy mistiness of the Grand Canal. It formed the opening spread in *Tavola*, the Italian magazine, for a feature that celebrated the weirdly beautiful paintings of the sixteenth-century surrealist, Giuseppe Arcimboldo, who created unlikely portraits composed of fruits or flowers, vegetables, fish or fowl.

The occasion for the photograph was a magnificent feast—in itself a gastronomic fantasy—made up of culinary specialities of the artist's own time and embellished with three-dimensional adaptations of his extraordinary still lifes. Ummarino's towering structure is in no way an Arcimboldo reproduction, but its fanciful composition accords harmoni-ously with the artist's work. The photographer "felt a passionate rapport" which came in part from the feelings conveyed to him by the Danieli chef, who worked with him on the shot, but even more strongly from within himself.

He is not certain how long he took to shoot the picture—"always as long as is needed, depending on the situation"—but all went smoothly with no technical hitches of any kind. On the rare occasions when difficulties do arise, they have far more to do with human relations, he believes, than with functional snags of any kind.

The same easy calm pervaded the shoot (overleaf)—also for *Tavola*—of the wedding day banquet for a daughter of one of the five Fendi sisters, the famous designers. It took place at the medieval castle of Prince Odescalchi at Lake Bracciano near Rome. The food was prepared by professional caterers. The photograph overleaf shows a detail of the table setting; it was luxurious and larger than life, all tulle, linen, crystal, ivory and gold.

Gianni Ummarino almost invariably shoots with studio flash and a variety of extra lights and reflectors, but he never uses filters or distorts or adjusts the truth of the colours in any other way. He is totally opposed to the artificial: he wants the food that he photographs to be edible, and he likes his props to consist of "the concrete objects that I find around me." His style and inspiration derive entirely from the empathy he feels with the things and people that he meets and with the world around him.

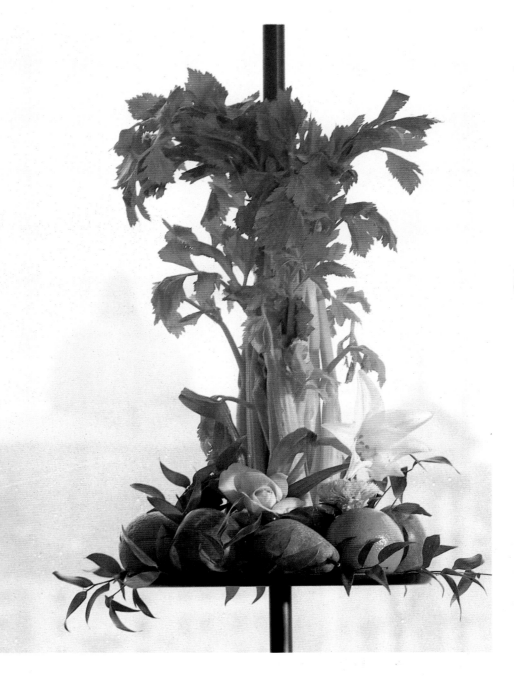

GIANNI UMMARINO

GIANNI UMMARINO
Via Rigola 1
20159 Milan
Italy

Major Publications

Magazines:
Brava
Casa Amica
Casa Viva
Gioia Casa
Grif
Interni
Rakam
Tavola

TECHNICAL DETAILS

Danieli still life
CAMERA: Hasselblad
FILM: Kodak Ektachrome 64 Professional
APERTURE: *f*16
SPEED: flash plus 1/2 second plus flash
 duration
LIGHT SOURCE: Elinchrom studio flash and
 various extra lights

Wedding breakfast
CAMERA: Hasselblad
FILM: Kodak Ektachrome 64 Professional
APERTURE: *f*11
SPEED: flash plus 1/4 second plus flash
 duration
LIGHT SOURCE: Elinchrom studio flash and
 various extra lights

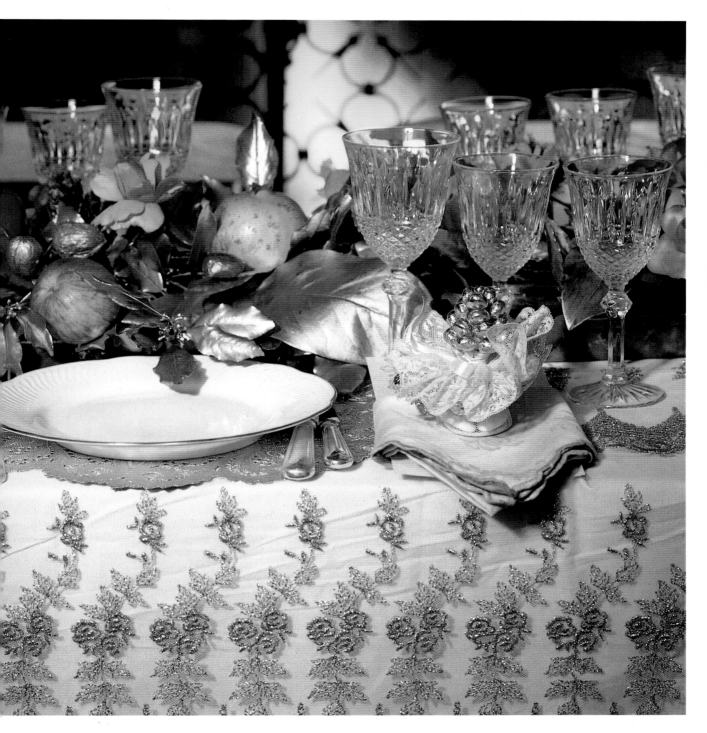

PAUL WEBSTER

PAUL WEBSTER became known as an ice cream specialist early in his career, the secret of which, he says, is not to be frightened by the quick-melting stuff. He was soon invited to take on other food assignments, and today they represent about 80 per cent of his work. He does a mixture of editorial photography, mostly for books, and of commercial work, mostly for packaging. The remainder of his time is spent on landscapes and still lifes for advertising for a variety of clients from fashion to industrial and institutional.

His own inventiveness has been spurred on more by other photographers than by painters, although "the Dutch school has certainly had some relevance." He likes to cook, but seldom tackles anything more ambitious than a casserole, and he occasionally puts together "extremely simple food arrangements" for his camera.

"I know it is a good picture," he says, "if somebody wants to eat something that I have photographed." Bringing this off, he feels, depends on a combination of effective lighting and placing the food in an appealing situation.

He concocted his evocative tea party to make his tableful of fruity, creamy dishes look irresistibly tempting. It is a late afternoon scene in the country in midsummer that he has painted, with the sun streaming through the open window and a light breeze stirring the curtain. He and Paula Alp, the food stylist (now his wife), selected the props together and built the set in his studio. The emphasis was on atmospheric touches—the fresh-cut flowers, straw hat, prettily wrapped presents, pieces of old-fashioned linen.

He shone two large tungsten spots through the window to achieve the warm afternoon light and enhanced this by reflection with four polyboards, each eight feet by four feet (2.4 × 1.2m), which he placed at the back of the set. In addition he suspended a large screen of diffusing material directly above the table to create a soft light overall.

Lisa Collard, a home economist, suggested the recipes and prepared them in Webster's studio kitchen. He then had to work fast before the fresh cream—he used real cream; no cheating, no doctoring—soured or discoloured. With two stylists and two assistants to help, it took him one day to prepare and to shoot four sheets of large-format film.

Both this photo and his see-through smoked salmon (overleaf) were taken for personal promotion, and they demonstrate totally different techniques. The second is a pure graphic concept which concentrates on the singularity of the fish. Webster had never seen its transparency featured this way, a quality that he underlined with the striated, translucent 1930s Shelley porcelain plate, the muslin cloth, and the thinly sliced lemon and cucumber. He emphasized it even further by standing the plate on a sheet of Plexiglass and lighting it from beneath with a flash strip. He shone a second strip from the side through a soft screen and added a tungsten spot for warmth. The only problem was to point up the texture of the cloth without losing the colour of the salmon.

Elaine Bastable, a food stylist, arranged the food. Webster and his assistant assembled everything else from his own stock of props (as a sideline, he runs a props company). It took about half a day, and he shot four sheets.

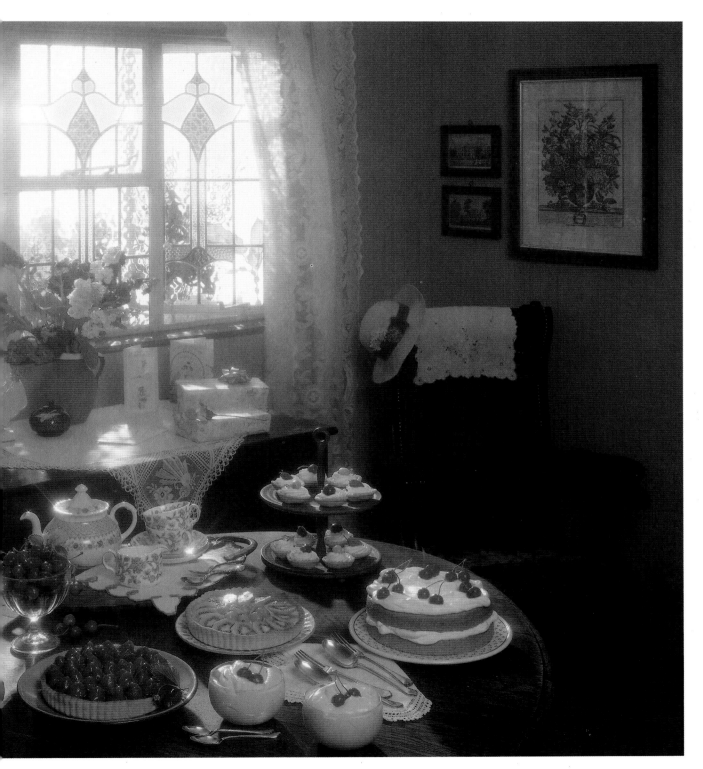

PAUL WEBSTER

PAUL WEBSTER
2c Macfarlane Road
London W12
United Kingdom

Major Publications

Books:

Carrier's Kitchen, Marshall Cavendish, London, 1980/81 (partwork)

The Country Heritage Cookbook, Northern Ireland Milk Marketing Board

Dairy Diaries for 1986 and 1987, Milk Marketing Board

Delectable Cakes, Marks & Spencer

Hostess Cookbook (A. Ager), Marks & Spencer, London, 1983

So This Is Kosher! (A. Kaye), Ward Lock, London, 1986; Salem House, Topsfield, 1986

Tempting Cheesecakes, Marks & Spencer

Packaging clients include Lyons Maid, Marks & Spencer and McVities. Advertising clients include Gucci, Kurt Geiger, British Telecom and GEC.

TECHNICAL DETAILS

Country tea party
CAMERA: Sinar Norma
FILM: Kodak Ektachrome 64
APERTURE: f45
SPEED: 35 seconds
LIGHT SOURCE: tungsten spots through window; 4 polyboards 8 feet×4 feet (2.4×1.2m); soft screen over table top

Smoked salmon
CAMERA: Sinar
FILM: Kodak Ektachrome 64
APERTURE: f64
SPEED: 10 seconds
LIGHT SOURCE: underlight, flash strip; strip over the top through soft screen; tungsten spot

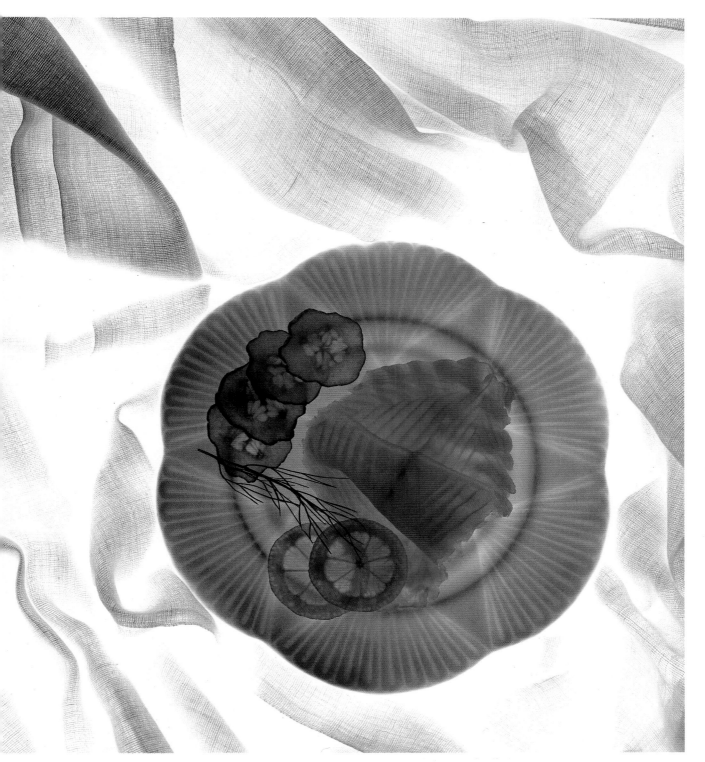

ROBERT WIGINGTON

ROBERT WIGINGTON doesn't consider himself an artist but he does acknowledge a strong debt to studies of the Old Masters, the Flemish school and the Impressionists. Among photographers, he particularly admires Irving Penn, Avedon and Art Kane.

About 90 cent of his work involves food. The rest is chiefly with china and glassware. He loves everything about food, including cooking it, but he seldom does it because Carole, his wife, feeds him and their three children so well.

He defines the job of the food photographer simply: "It is *selling* food." He never loses sight of that, whether he is doing editorial, advertising or packaging shots. When he illustrates a cook book, the point is "to get the readers making and eating." On a package or in an advertisement, it is to get them buying.

Like almost everyone in the business, Wigington is happiest with editorial work, for the obvious reason that, although it pays far less than the others, it compensates with relative creative freedom. But he doesn't chafe at the restraints of the "big bucks" side; on the contrary, he considers them a challenge.

Even when he is given cast-iron instructions—for, say, the label on a can, using specific colours and a predetermined format—he tries to inject a touch of ingenuity, to enhance the client's concept.

His approach to all food work is psychological. He feels that the picture should conjure up an aura. The average person doesn't stop to think about the dish when it is placed in front of him, he simply goes ahead and eats it. The photograph, however, can make the same person take the time to examine details, to stress associations, to tantalize the senses.

To Robert Wigington the highlight is the most telling aspect of a picture. More than anything else, it delineates each type of food. On a piece of cheese, it is so soft that it is almost non-existent.

On an apple it is brilliant, but gentler on a plum. "The highlight not only describes the food," he says, "but tells you how it has been cooked—glowing moistly for a roast of beef, strong and shining for barbecued sausages."

His skill with the subtle variations of the highlight is clearly seen in both his salmon (overleaf) and grape granita shots. He chose these two out of thousands of pictures he has produced over more than two decades, "because people seem to like them." They also demonstrate another characteristic of his work—preoccupation with textures. He often paints his own backgrounds.

In the salmon picture, one of three illustrating an article on Canadian salmon in *Recipes Only* magazine, he used the same background for all— the unpolished side of a slab of pink marble. In the same way, the green marble was the common denominator for a series on grape cooking in *Toronto Life* magazine.

Wigington loosely discussed the approach for both shots with the respective art editors after which he was free to do pretty much as he chose. In both cases the food was prepared in his studio kitchen by Kate Bush, a food stylist. It was set up with the aid of one assistant, shot with a single light source and made deliberately contrasty.

Both sessions were straightforward: a longish day in the studio, with four exposures for each photograph.

The food was not distorted in any way. Wigington will never let his photos lie. What he shoots must be legitimately what it is, and all the props must be authentic. But he may tinker ever so slightly with the truth, taking a bit of artistic license to coax the head on a mug of beer, for instance, to a photogenic degree of frothiness with a rubber syringe; intensify the steam above a cup of coffee with a puff of cigar smoke, or to highlight the highlight on a fried potato with a light touch of oil. "If you want one single bubble in a glass of wine, it won't just happen," he says. "You have to put it there."

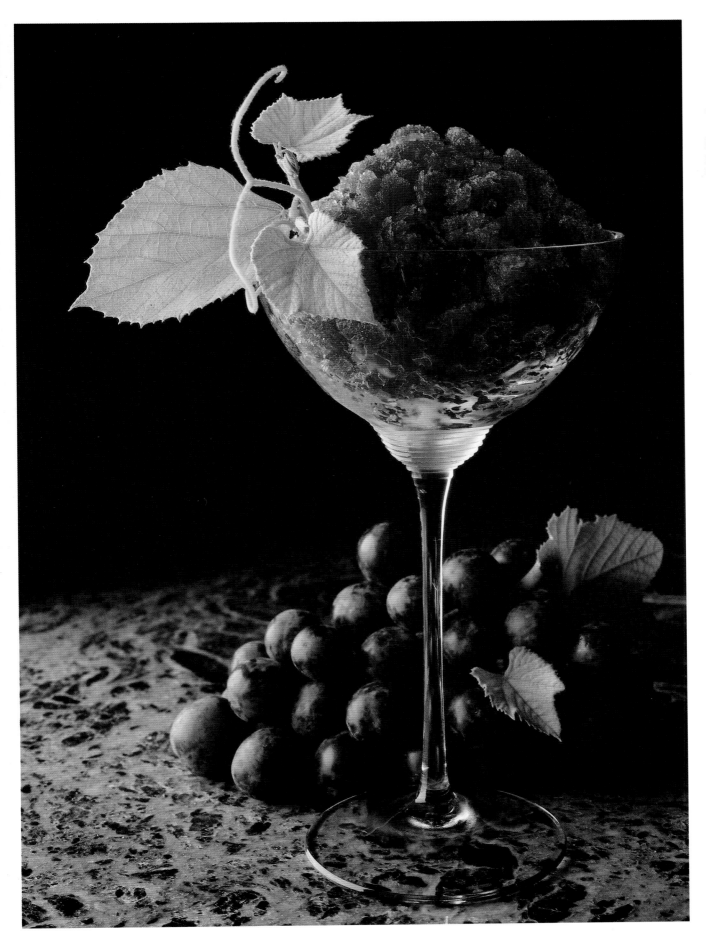

ROBERT WIGINGTON

ROBERT WIGINGTON
4 Clinton Place
Toronto
Ontario
Canada

Major Publications
Book:
Toronto Life Food Book, 1975

Magazines:
Recipes Only
Toronto Life

Commercial clients include General
Foods, Dairy Bureau of Canada, Borden
Co Ltd., Nestlé, Gilbey's, Pillsbury,
Lever Bros., Libby's, Campbells, Arrow
Shirts, Ontario Milk Marketing Board.

Awards

Holds a number of Art Directors Awards

TECHNICAL DETAILS

Grape granita
CAMERA: Sinar P
FILM: Kodak Ektachrome 64
LIGHT SOURCE: bank light; 2 flash heads,
 8,000 watt/seconds

Canadian salmon
CAMERA: Sinar P
FILM: Kodak Ektachrome 64
LIGHT SOURCE: bank light; 2 flash heads,
 8,000 watt/seconds

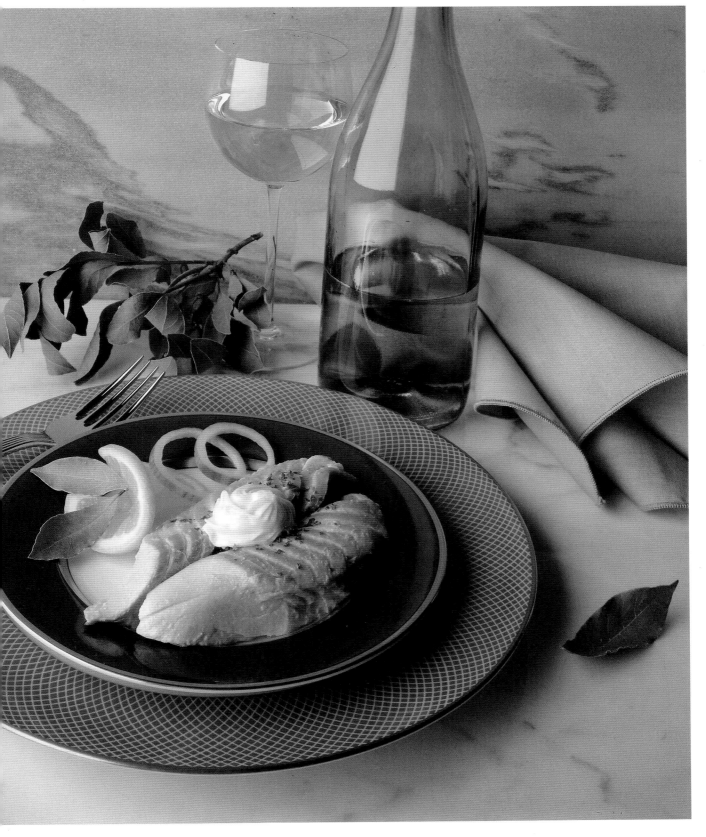

HIROYUKI YAMAMOTO

HIROYUKI YAMAMOTO, who works almost exclusively with food, feels that he came into his profession naturally. "It might run in my blood," he says. "My father was a cook." His style has developed out of his own instinctive feeling for food. Although his gastronomic interests are international, and in Tokyo he can eat food from all around the world, he remains loyal to the cuisine of his native land. He cooks both Japanese and Chinese meals and he often photographs dishes he has prepared himself.

He always strives to make a statement that is recognizably Japanese, as limpid and uncluttered as a classic flower arrangement. Simplicity is its keynote. He chose the garlic and green plums (overleaf) because they so clearly express his attitude towards his work.

The first was published in *Art Directors' Index*, no. 12 (1986), and the second, enlarged to poster size, was used to publicize his second photographic exhibition. Their "Japanese-ness" is underlined by his choice of background, a slightly textured black plastic board for the first shot, and, for the second, a plain black cloth arranged with a white board—part of a container for *Wagashi* (Japanese sweets)—which bears a pattern of plum blossom.

Yamamoto is particularly keen on using fresh fruits, vegetables and herbs, and likes to capture them absolutely pristine, newly picked from the field or the orchard. He has them packed and transported as carefully as though they were fragile porcelain, and he handles them delicately in the studio so that none of the bloom is lost.

Whenever possible he tries to shoot foods in season when they are "at their best, both in shape and in colour." He resists using produce that is forced; to his discerning eye it is as unphotogenic as it is lacking in flavour.

The green plums, delicious as they look, are never eaten fresh but are pickled as a condiment or made into a liqueur, a beverage that has been popular in Japan for centuries.

Neither of his two images presented any serious difficulty. The only problem with the garlic was keeping all the brittle strands intact. For the plums, he set his studio temperature uncomfortably low, in order to preserve their freshness, and he made his decisions on lighting and camera angle as quickly as possible.

With two assistants in the studio, each shot was completed in about three hours, with some thirty-two exposures for the first and twenty-two for the second. He used numerous flash units in both cases—Balcar 5,000, 2,400 and 1,200 watt/seconds. To anticipate the colour results, he took test shots with film of the same emulsion number.

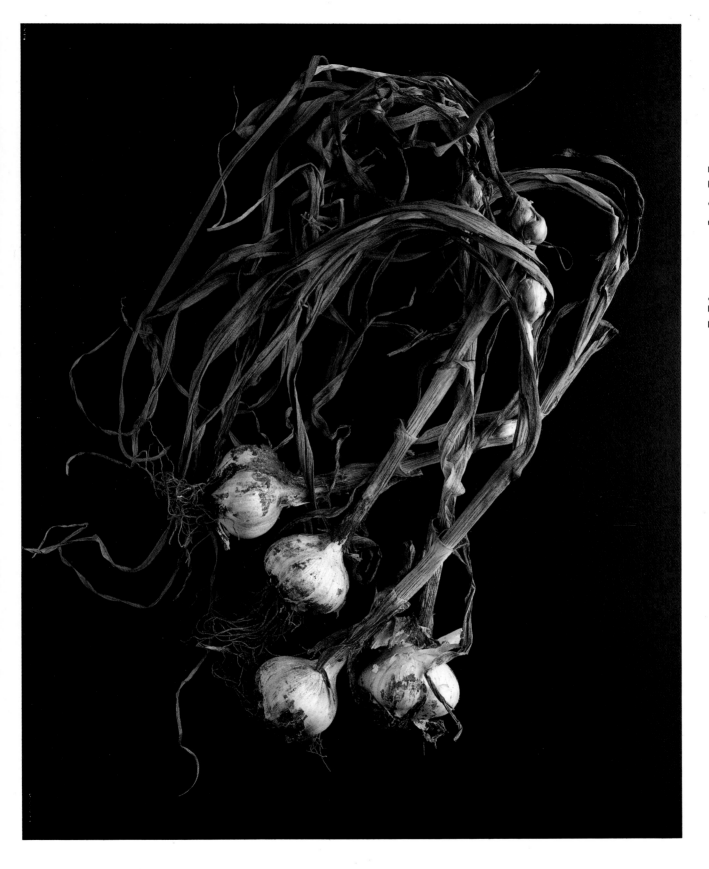

HIROYUKI YAMAMOTO

HIROYUKI YAMAMOTO
Ryowa Building 301
9-5-29 Akasaka
Manato-Ku
Tokyo 107
Japan

Works for a variety of commercial
clients.

TECHNICAL DETAILS

Garlic
CAMERA: Plaubel Makina Profia
FILM: Kodak Ektachrome 64
APERTURE: $f6.3$
LIGHT SOURCE: Balcar flash, 5,000, 2,400 and
 1,200 watt/seconds

Green plums
CAMERA: Canon F-1n
FILM: Kodachrome 25
LIGHT SOURCE: Balcar flash, 5,000, 2,400 and
 1,200 watt/seconds

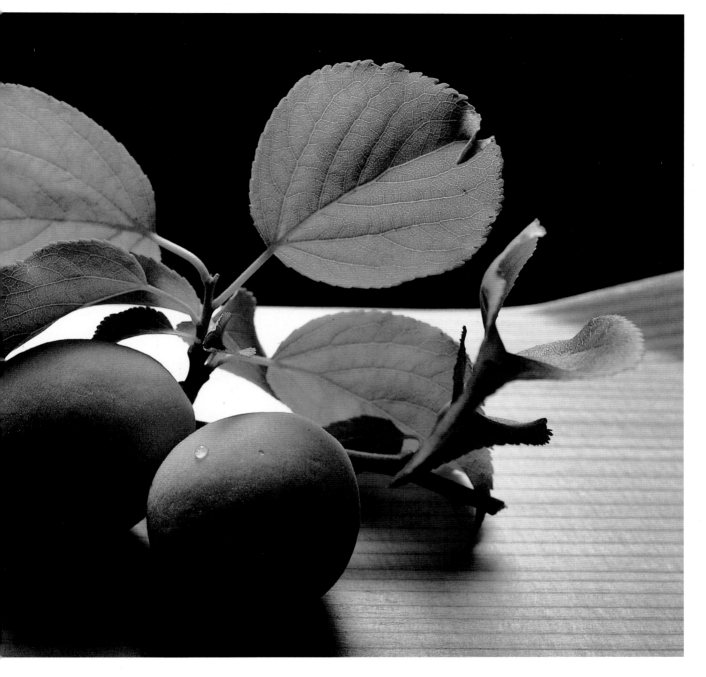

Hiroyuki Yamamoto

Bibliography

American Heritage Cookbook and Illustrated History of American Eating and Drinking, American Heritage Publishing Co Inc, New York, 1964.

Braine, Michael F., *The Era of the Photograph*, Thames and Hudson, London, 1966.

Coe, Brian, *Colour Photography: The First Hundred Years*, Ash and Grant, London, 1978.

Coe, Brian, *The Birth of Photography*, Ash and Grant, London, 1976.

FMR, Jan/Feb 1987, Number 20, Franco Maria Ricci, Milan.

Montagné, Prosper, with Dr Gottschalk, *Larousse Gastronomique*, Augé, Gillon, Hollier-Larousse, Moreau et Cie, Paris, 1983.

Montagné, Prosper, with Dr Gottschalk, *Larousse Gastronomique*, ed. Nina Froud and Charlotte Turgeon, Paul Hamlyn Ltd, London, 1961.

Pullar, Philippa, *Consuming Passions*, Hamish Hamilton Ltd, London, 1970.

Sykes, Christopher Simon, *Country House Photography*, George Weidenfeld and Nicolson, London, 1980.

Westbury Collection of Cookery Books (catalogue), Sotheby and Co, London, 1965.

Wijey, Mabel, *Warne's Everyday Cookery*, Frederick Warne and Co Ltd, New York and London, 1929.

Wilson, C. Anne, *Food and Drink in Britain*, Constable, London, 1973.

Acknowledgements

Many people have been generous with their time and expertise in helping to bring *Food in Focus* into existence, most of all, the photographers whose work enriches these pages. Special thanks go also to Ellen Galford, Time-Life Books, London, and to Natasha Honan, Rotovision, London, for making research facilities available.

Out grateful thanks to the following for providing us with illustrations: The Bridgeman Art Library (pp. 6 top, 9 top), The Fox Talbot Museum (p. 9 bottom), The Mansell Collection (pp. 7, 8 bottom, 10 top), Mary Evans Picture Library (p. 10 bottom).

Index